packaging graphics

ROCKPORT

GLOUCESTER MASSACHUSETTS

ROCKPORT
PUBLISHERS

Renée Phillips

packaging graphics

First published in the United States of America by
Rockport Publishers, Inc.
33 Commercial Street
Gloucester, Massachusetts 01930-5089
Telephone: (978) 282-9590
Focsimile: (978) 283-2742
URL: www.rockpub.com

ISBN 1-56496-817-0

10 9 8 7 6 5 4 3 2 1

Design: Stoltze Design

Printed in China.

I would like to thank the following people: Catharine Fishel, for her advice and support. Shawna Mullen, for her direction (and for putting up with me). My parents, Ken and Judy Phillips, for their words of encouragement. And, finally, my husband, Tim Thomas, who helped make this project possible.

Acknowledgments

contents

introduction

Although the box it is packaged in is rather dull, most designers, retailers, and marketers would agree that the iMac is one of the most successfully packaged products of the last few years. The product—a user-friendly computer promising three-step Internet access—is beautifully packaged in an all-in-one, translucent blue-and-white nugget.

This leads to a long-standing debate about which takes precedence: product design or packaging design. Ask any product designer and he or she will tell you that the product is the most important thing. After all, customers buy products. Ask any packaging designer, and you'll hear that the packaging is more important. After all, without a great package the product may never even get noticed.

In reality, the lines between product design and packaging design have always been blurred. In many cases—such as the iMac—the packaging is the product. In order to sell something liquid like a beverage or a skin-care product, you have to create a container that holds the product while branding it effectively. The branding or visual equity of the iMac is so high that it has spawned a wide range of products with a similar translucent blue-and-white look, such as secondary drives, mice, scanners, CD holders, and other desk accessories. Not only are these products designed to look like the computer they are used with, they are packaged so that consumers can see their similar colors and materials.

The design of the iMac isn't the only reason for its success. Apple Computer's successful television advertising campaign boosted knowledge of the product and improved sales. Advertising and packaging have always been related. Television, radio, print, and Web-page ads create the knowledge of and the desire for products. Spend a few minutes watching television ads or looking through print ads—it's rare that the packaged product is not shown. The packaged product, on the supermarket shelf, reminds the buyer of the ad and offers the potential customer more. A package can be picked up, examined, labels can be read, and price considered—all in the space of a few seconds. And, if the advertising and the packaging are successful, the consumer won't even need to consider the purchase, he or she will pick up the package and head straight to the checkout counter.

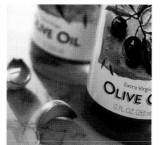

basic packaging

Designers who create direct-mail pieces know that they only have five seconds to catch a reader's attention. Designers who create packaging may have even less time. Unless a customer is looking for a specific brand or product, a package's design may only have two to three seconds to get a shopper's attention as he or she passes it on a store shelf.

In today's world of warehouse shopping and overabundance, where consumers can choose from a vast array of products in a variety of complex packaging, simple packaging designs may be one of the easiest ways to catch consumers' eyes. When competing on store shelves against designs with too many typefaces, colors, unnecessary bursts, banners, and other art elements, a simple design causes the eye to stop, rest, and take notice of the product.

It has been said that the egg is the best example of simple, functional packaging. While that may be true, no one would ever claim that an egg was graphically appealing due to its bold use of color, type, and material. The shell, or packaging, of the egg is valued because of its pleasing form and its function. These are also the reasons we value simple packaging, but simple product packaging must go beyond form and function. Simple, effective packaging must quickly communicate what the product is, must make selection simple, and must stand out from the competition.

The pieces featured in this section use a variety of approaches to stand out from the competition. Some rely on color, some use special metallic or transparent inks, some use unusual artwork, some use uniquely shaped bottles or boxes—all are effective.

design firm
Design Guys, Inc.
creative director
Steve Sikora

Michael Graves/Target

These simple, minimal package designs work because the products are merchandised together in small in-store concept shops. The firm designed packages for over one hundred products in the kitchen, garden, and decorative home accessories categories. Although product manufacturing took place in several countries, for consistency all printing was done at a single source in Hong Kong. It was the only way to consistently match the blue (an important color from their product color palette), which belongs to no color system. A dull laminate gives the boxes a velvety surface and softens the blue just a bit.

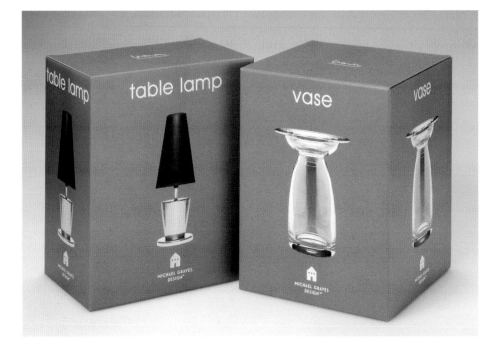

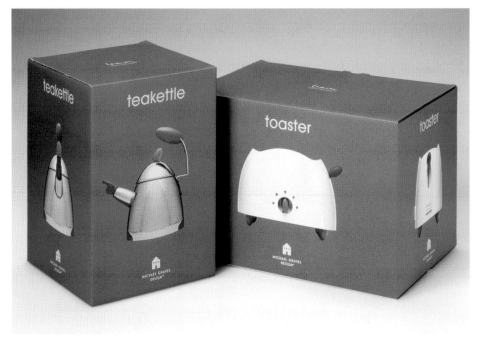

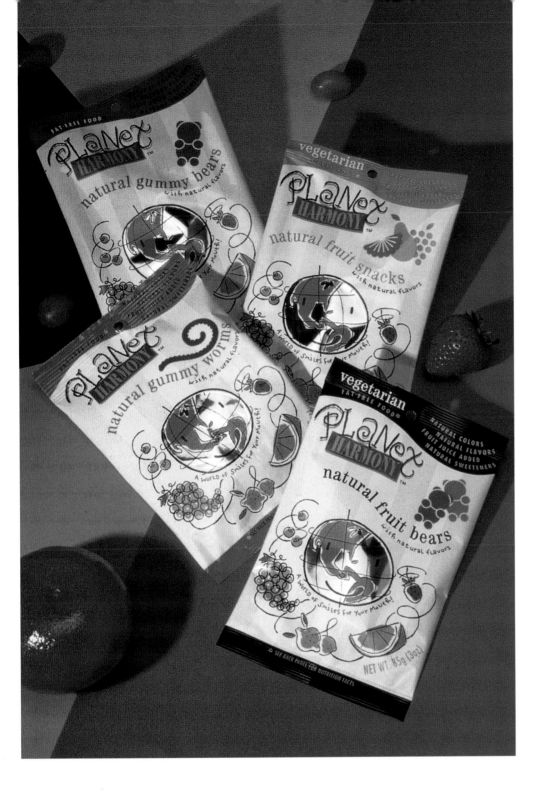

design firm
Thorp Did It
designers
Rick Thorp, Nicole Coleman
illustrator
Word Schumoker

Planet Harmony

Planet Harmony is a new line of natural snacks for the established Harmony brand. These "yummy treats with a healthy spin" come from "a junk-free zone." The design objectives were to make the package fun and informative while establishing a strong brand and shelf presence unlike anything else in the natural-food category. The bags were printed on a special metallized film; some of the inks are transparent to give a mirrored look.

design firm
Thumbnail Productions Inc.
art director
Rik Klingle
designers
Judith Austin, Valerie Turnbull
illustrator
Judith Austin

The Marine Ecology Station

The Marine Ecology Station is a real, working, floating marine laboratory; they wanted to project an environmentally friendly image that differentiated them from the typical area tourist traps. Since they are a non-profit organization, their budget was practically non-existent. So a flexible logo was the key to this packaging system. The entire system was printed in a single color on a recycled Kraft stock. The packaging has since been rolled out into merchandising, including a line of clothing.

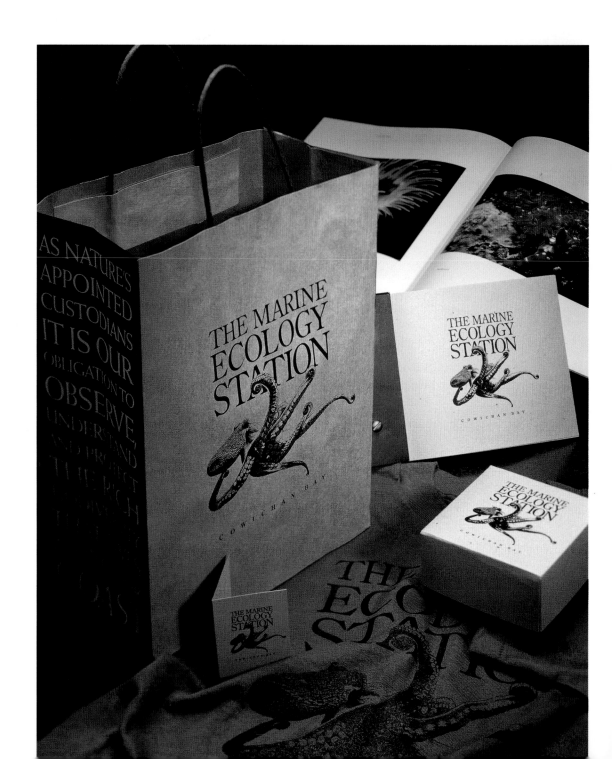

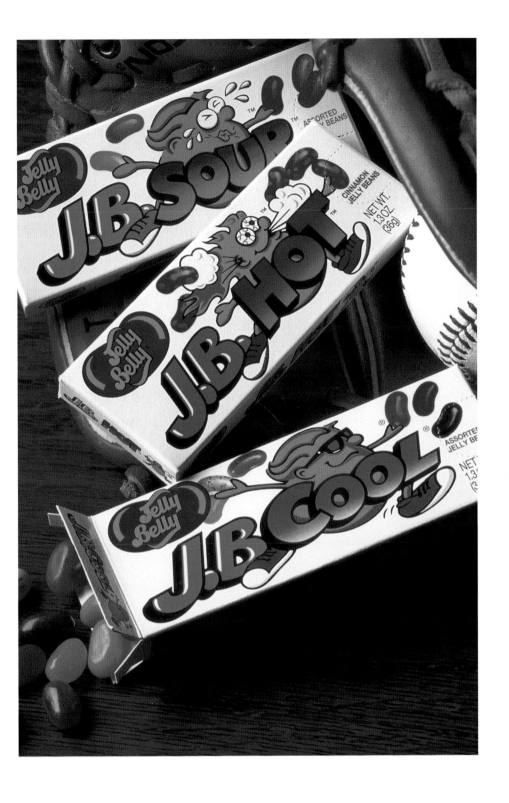

design firm
Addis Group
art director
Steve Addis

Goelitz Candy Company

Packaging a familiar product in a new way often increases sales. Jelly Belly gourmet jelly beans are usually sold loose by weight or in boxes of assorted flavors. Here, the beans are packaged according to three tastes—hot, cool, and sour—with a cartoon jelly bean included to liven up the label.

design firm
Thumbnail Productions Inc.
art director
Judy Austin
designers
Valerie Turnbull, Rik Klingle
illustrator
Jennifer Hewitson

Que Paso Snack Chips

The focus of each of these chip bags draws on the rich traditions of Mexican food. A flecked, matte finish was developed to give the packages a sense of heritage and handcrafted quality. The scratchboard illustrations that dominate each bag were designed to be viewed together as one continuous scene—from harvest, to market, to kitchen, romanticizing the process by which the product is brought to the consumer.

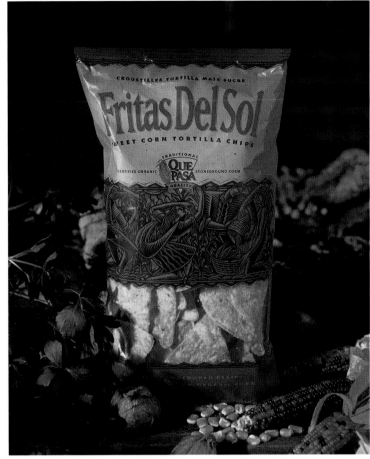

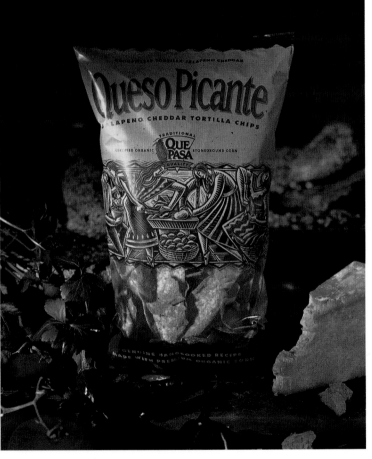

design firm
Louisa Sugar Design
creative director
Louisa Sugar
designer
Louisa Sugar
illustrator
Susan Bercu

Cristley's Cookie Packaging

The assignment was to create a gourmet look for a line of healthy cookies made with rice flour. For the background of each box, gradations of deep jewel tones were used to indicate richness; black borders frame the design and reinforce the gourmet look. The whimsical brush illustration of a rice plant wraps around three sides of the box; on the bottom panel you can see the rice growing out of water.

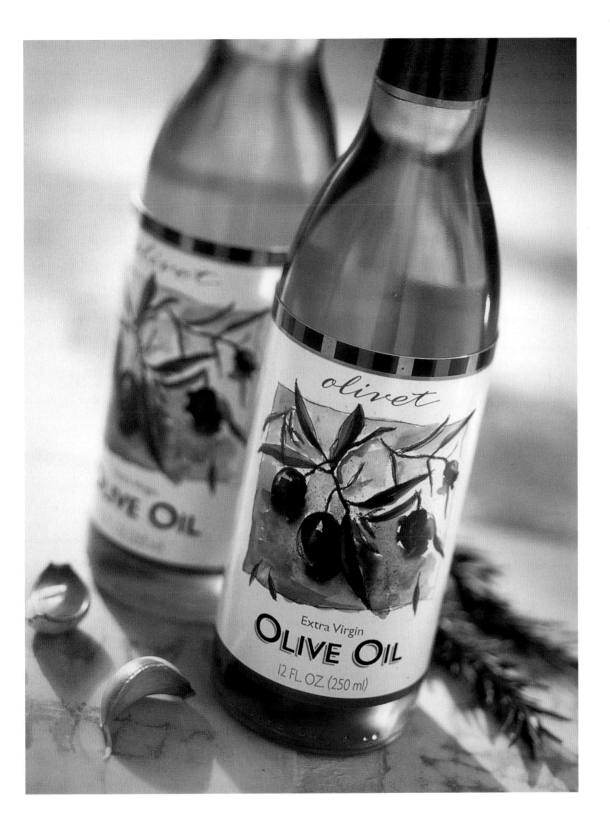

design firm
Louise Sugar Design
creative director
Louise Sugar
designer
Louise Sugar
illustrator
Beth O'Rourke
hand lettering
Donald Churchfield

Olivet Olive Oil

An artistic watercolor impression of olives and a hand-lettered script logo are among the details used to convey the artisan quality of this extra-virgin California olive oil. Small areas of the watercolor are repeated in the top border stripes, and subtle accents of gold reinforce the label's premium look. This look differentiates the brand from its shelf competition; most of which favors an antique, engraved look.

design firm
Design Guys, Inc.
creative director
Steve Sikora

Bath & Body Works

Bath & Body Works wanted to develop a summer in-and-out line of fun body splashes—Splash Emotions. The premise was that rather than sell the product by fragrance, the splashes would be sold based on how they made the user feel. The curvy little bottles, simple graphics, bright colors, and casual, script typeface urge consumers to pick them up and try the fragrances on.

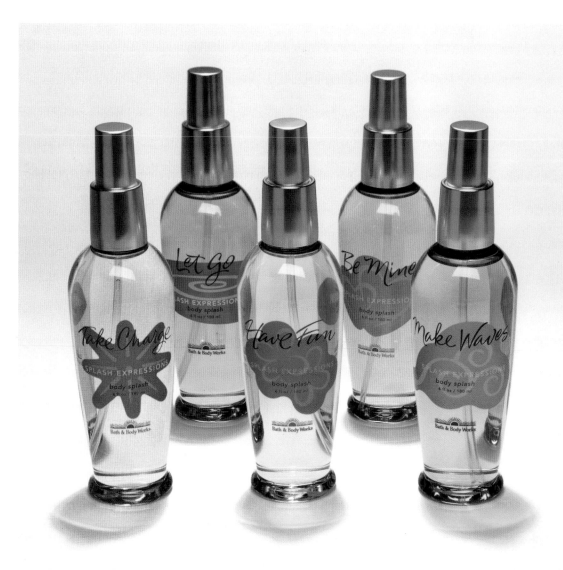

OrganicSelect® TURF

Carbon:nitrogen-based formula for superior lawn growth

Derived from vegetable proteins and carbohydrates

Supplemented with porcine bone and meat meal for the increased nitrogen needs of your lawn

Contains no chemicals: will not burn—you cannot overapply

Contains no manure or sewage sludge

Optimizes soil conditions that facilitate biological activity

Increases soil organic matter content

Non-toxic: safe for children and pets

Slow release means only two applications per season

Controls thatch buildup

4–4–1

25 lbs treats 3,500 sq ft

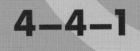

design firm
Benson & Hepker
designer
Joan Benson

BioResource, Inc.

This bag of organic lawn fertilizer features bold type and attention-getting blocks of color. While checking out the competition, the designer found the organic products on the shelf tended to use muted earth tones, while the non-organic products used mostly bright primary colors. The printed bags repeat the circle of grass, the product name, the word organic, and the company name on the sides of the bag so that when they're stacked, you can still see the word Turf, the o, and the grass from a distance.

design firm
Studio Flux
art director
Holly Utech
designers
Holly Utech, John Moes

Target

Target asked Studio Flux to redesign their existing three-color, ninety-nine-cent kitchen-gadget packaging to be black on chipboard. The underlying challenge was to create packaging that was cost-effective without looking cheap. The solution is simple and clear, and suits the target audience. Also, as there is little ink coverage, it is an environmentally friendly solution.

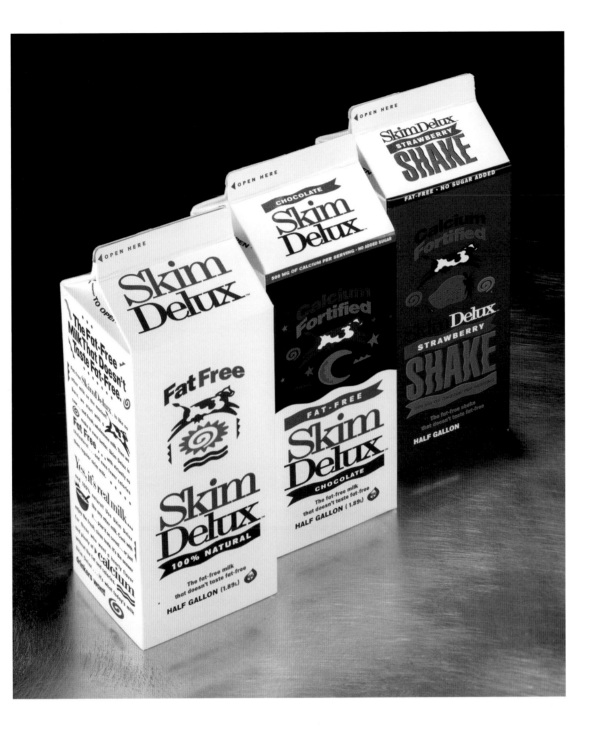

design firm
Gretemon Group
art director
Sonio Gretemon
designer
James Strange

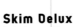

Skim Delux

A similar graphic treatment was used for each product in this line of fat-free flavored milk. A cow jumps over a sun, moon, and strawberry to denote the plain, chocolate, and the strawberry shake flavors, respectively. The cartons for the chocolate and the strawberry shake flavors use color to increase shelf recognition.

design firm
Greteman Group
art directors
Sonia Greteman, James Strange
designer
James Strange
illustrator
James Strange
production artist
Jo Quillon

ZiPani Breads Café

The design for the ZiPani Breads Café bag and cups are carried over to the café's retail products. Labeling is minimal on the dipping oils and sauce mixes to allow the customer to see the product. The labels for the cream cheeses, while still in the same style as the store's shopping bags and other products, are a bit more elaborate. Because the containers are opaque and usually stacked in a refrigerated display case, the label designs feature an identifying element for each different flavor.

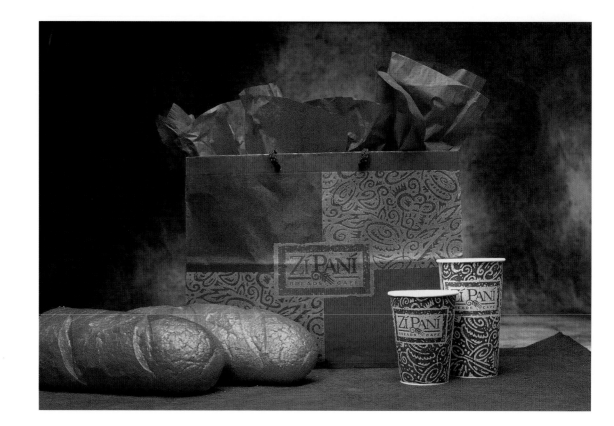

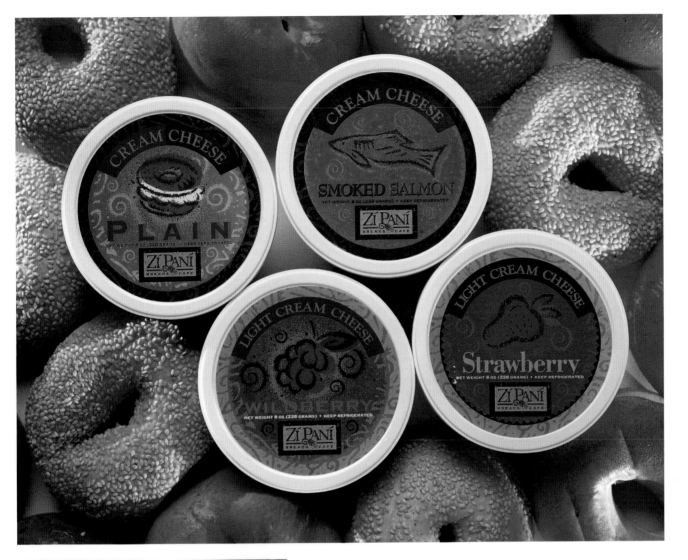

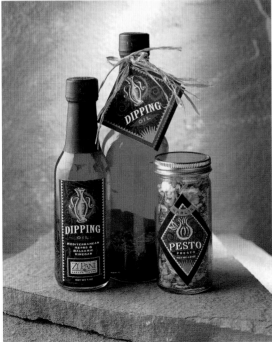

design firm
Mires Design, Inc.
art director
José A. Serrano
designers
José A. Serrano, Deborah Horn
photographer
Carl Vanderschuit

Qualcomm

For Qualcomm, Mires Design's strategy is to show people and products interacting. This helps bring out the human element in some very high-tech products. For the TGP packaging (shown on this page), the designers used distinct individuals and colors to position each product for a different market segment. The photos used for the peripherals packaging (the batteries, phone cases, and so on) were carefully chosen and positioned to accent, but not overwhelm, the product.

When developing the packaging program for Qualcomm's line of high-end CDMA phones (shown on the opposite page), the firm set out to create a unique brand that was still tied in to the existing look of the company's other products.

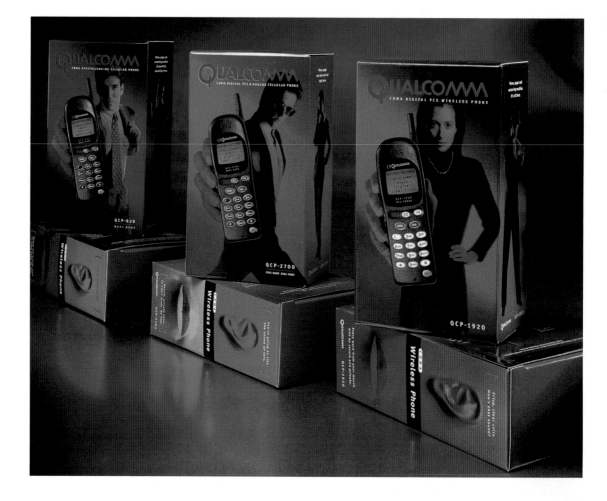

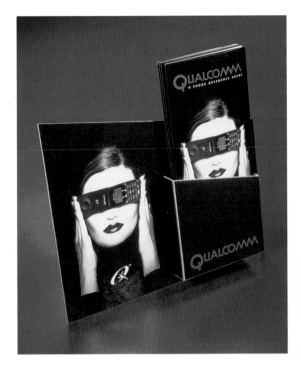

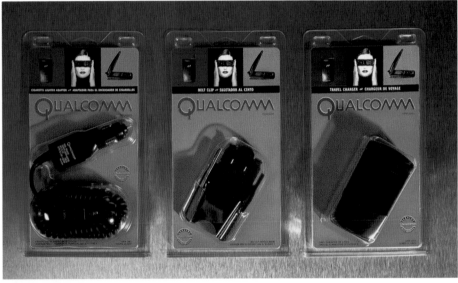

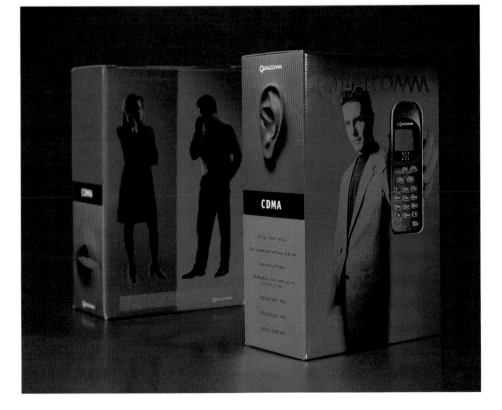

design firm
Michael Osborne Design
art director
Michael Osborne
designer
Andy Combouris

Logitech (Dexxa)

Simple product nomenclature and a straightforward photography style were used to communicate to an international market for the packaging of this line of peripheral hardware. A bold orange bar at the bottom of each package contrasts with the blue-and-white background of each design and provides a space to list the product's attributes.

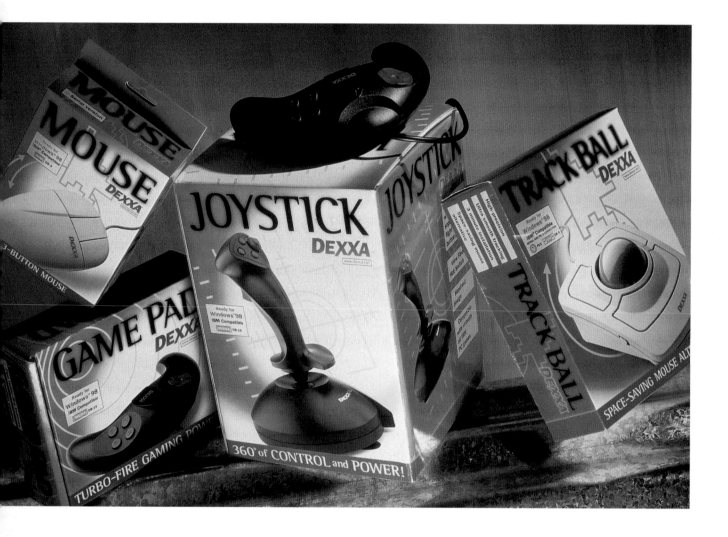

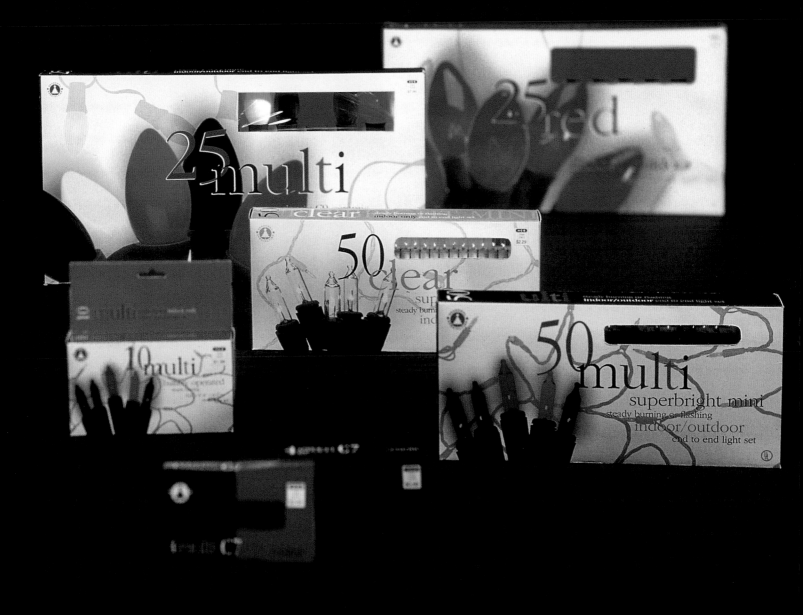

design firm
Seasonal Specialties LLC
creative director
Jennifer Sheeler
art director
Barbara J. Roth
designers
Lisa Milan, Jennifer Sheeler, Barbara J. Roth
illustrator
Drew Trampe
photographer
HEB Stores

HEB Holiday Light Packaging

The designers at Seasonal Specialties chose to forgo the usual red and green boxes when they created the packaging for HEB Stores' holiday lights. Instead, a simple white background sets off extreme close-ups of the lights, while small, die-cut windows show the consumer the actual product. To make product identification even easier, the type on the boxes is set in the color of the lights inside—multicolored, red, or clear.

design firm
Nuno Alves
designer
Nuno Alves

Baby Line

This line of baby skin-care products is sold in pharmacies, where the packaging is often very clean but usually lacking in human reference. The photos used on the packaging are positioned to work together to create a strong visual impact on the shelf. Additionally, the photos of smiling babies are repeated on several sides, so that no matter how the boxes are displayed on the shelf, the viewer sees the identifying visual.

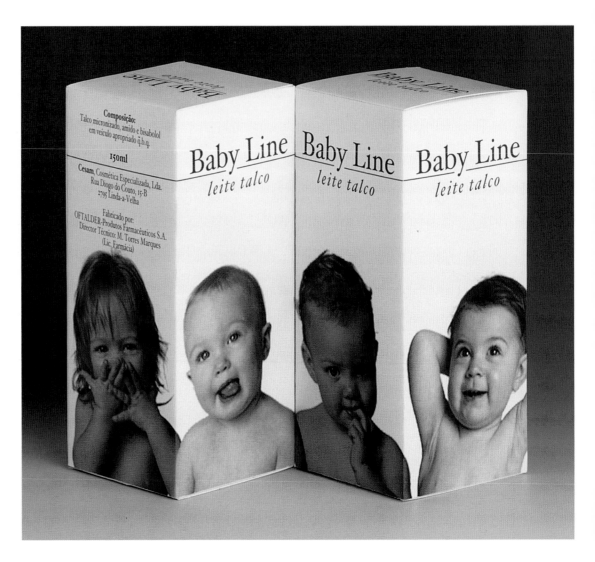

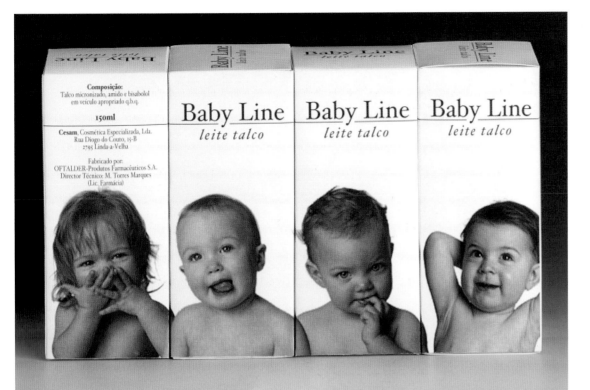

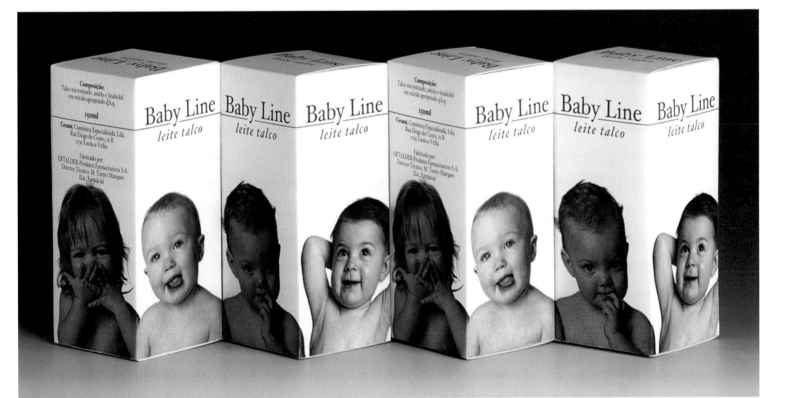

design firm
Blackburn's Design Consultants
designer
Belinda Duggan

Aqualibra

This redesign of an ailing brand focuses on balance, simplicity, and elegance. The firm created a simple identity for the beverages by balancing the Aqualibra brand name atop a triangle filled with fruit—each triangle contains a subtle A shape within the fruit. The new bottle works well with the new brand identity, as it creates its own subtle A shape by dramatically narrowing at the neck.

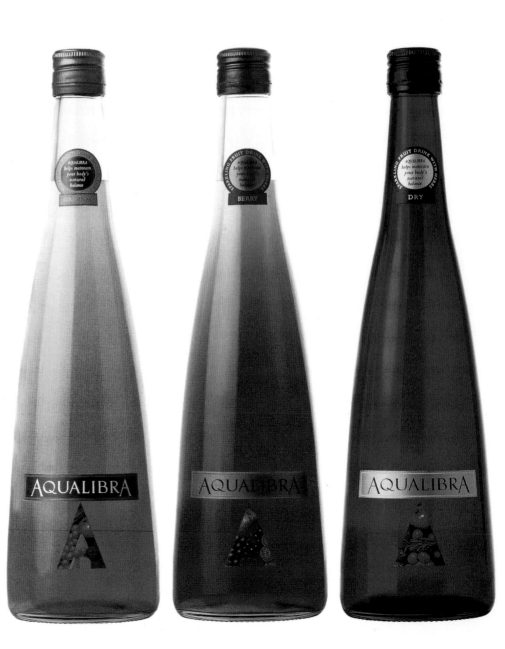

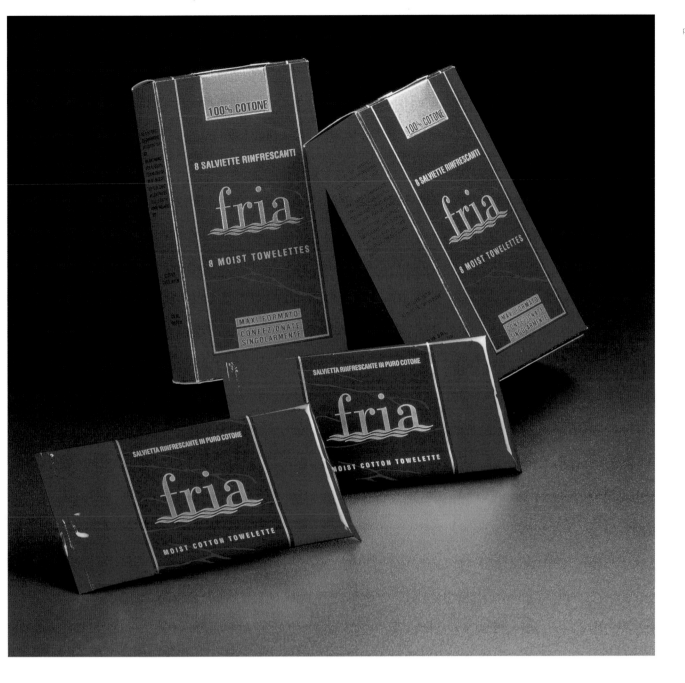

design firm
Studio GT&P di Gionluigi Tobonelli
art director
Gionluigi Tobonelli

DIVA International s.r.l.
To create an upscale look for these moist cotton towelettes, sold at select perfumeries and chemists, the designers used blind embossing and gilt for the boxes, and three-color gravure process for the sachets. Both the gilt and reversed type contrast nicely with the dark blue label.

design firm
Twist
art director
Kristine Anderson
designer
Kristine Anderson

Haddouch Gourmet Imports

Rich texture and vibrant colors create the perfect identity for this gourmet line of Moroccan Foods. The labels on the jars and bottles are large enough to be eye-catching on a crowded shelf, yet small enough to let the consumer see the product inside the container. The larger wrap-around label used on the boxes both showcase the brand's name and show off the intricate texture used for the designs.

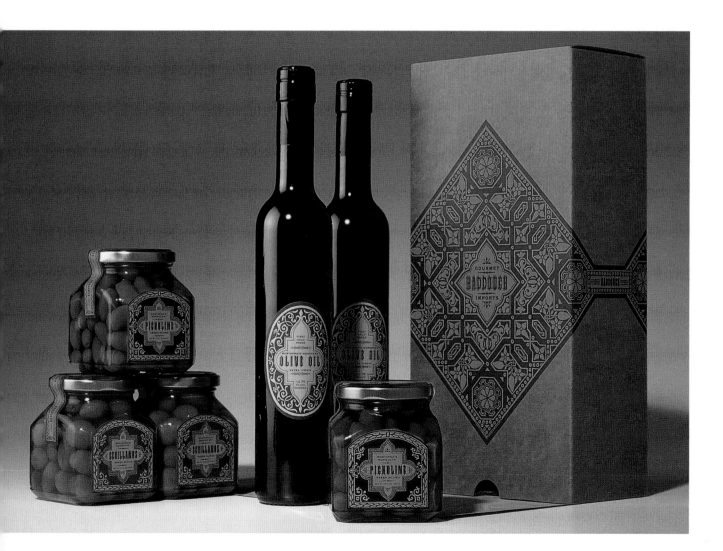

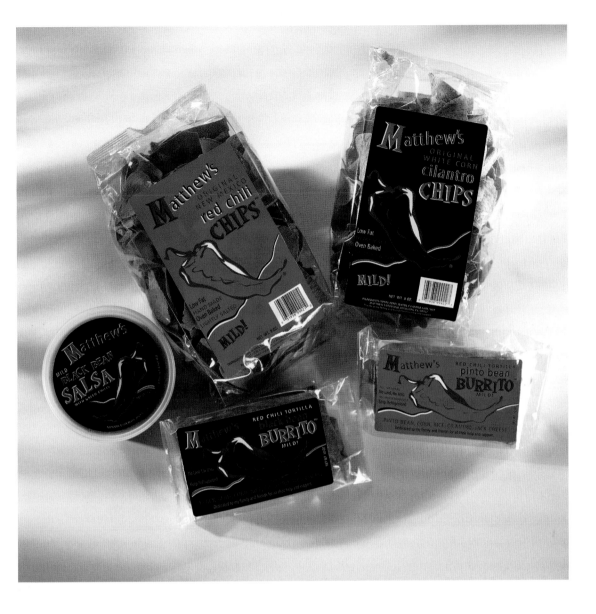

design firm
Pot Corney Studio
art director
Lizobeth Montgomery
designer
Lizobeth Montgomery

Motthew's Mexican Foods

A simple graphic, playful type treatment, and a bold color scheme make the labels for these Mexican foods—chips, salsa, and burritos—stand out. The background and type colors vary on each product to create consumer recognition.

design firm
Sibley/Peteet Design

Bellagio

These luxury bath items and gourmet foods were designed as retail products for the Bellagio (an exclusive resort in Las Vegas, Nevada). The food packaging uses a similar color scheme and type treatment on all of the product labels. The pasta sauce and olive oil both use rustic closures for a more authentic Italian look—the olive oil bottle is sealed with a cork and wax, and a wooden stopper is tied to the neck of the bottle.

The bath items have their own identity distinct from the gourmet food line, yet they are still tied in to the identity of the resort via the script B used on the packaging. The muted colors, striped background, and a recurring visual used on all of the product labels create a consistent look.

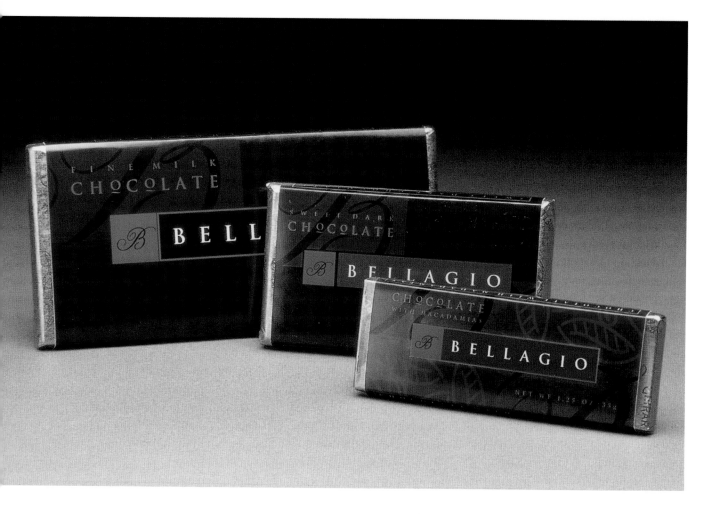

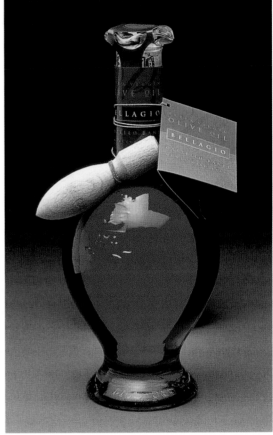

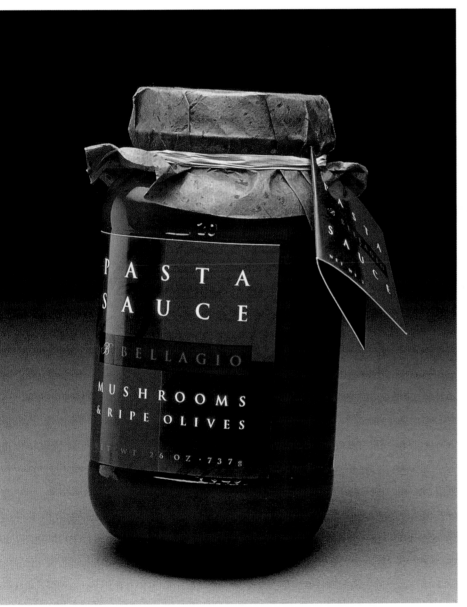

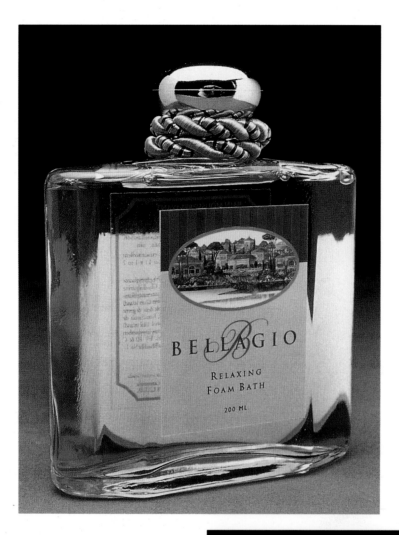

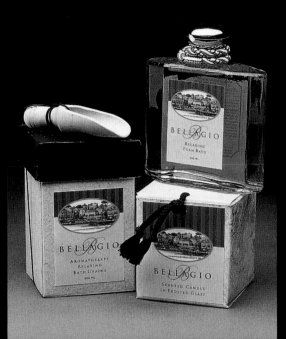

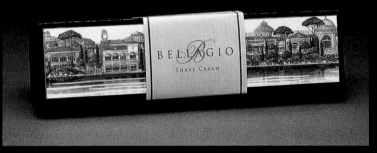

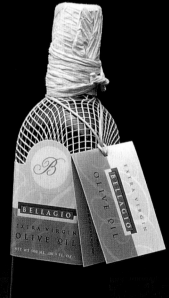

design firm

Göthberg + Co Design ob

designer

Benęt Göthberg

Stora Fine Paper AB

These products from Stora Fine Papers (Sweden) all use a similar, quickly recognizable graphic of staggered, thick and thin bars on their labels, boxes, and packages. The designer created a similar look for wine labels, carriers, and shopping bags as part of the corporate identity for StoraPapirkir, the Budapest merchant of Stora Enzo.

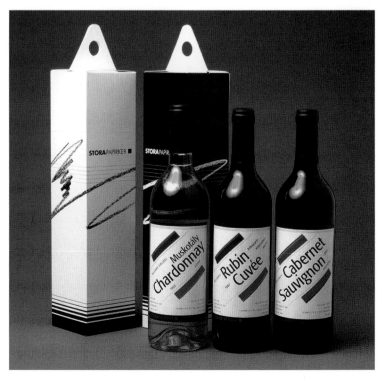

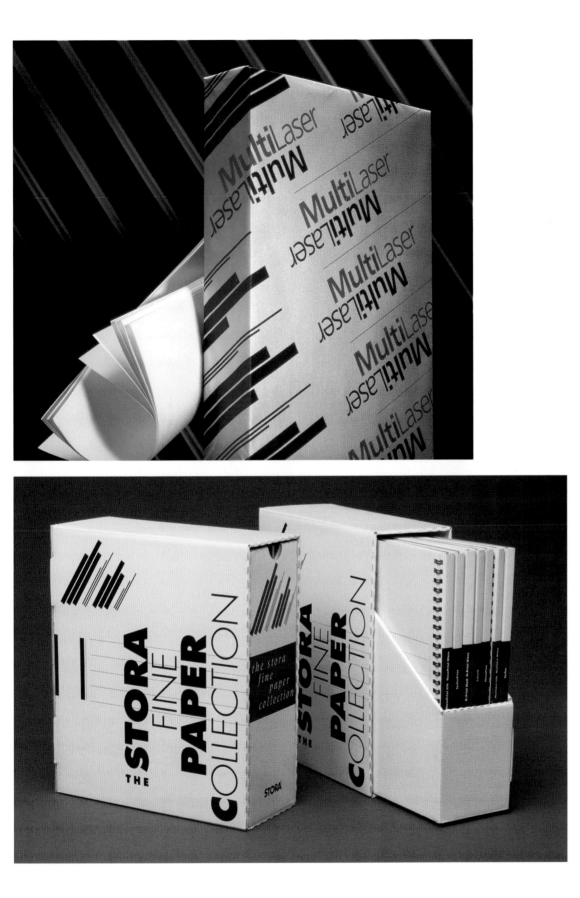

design firm
CEMK Advertising Agency Gothenburg
creative director
Olo Inser

Runebeer Wynja

Runebeer Wynja is made in Östergötland, Sweden, which is an area known to be full of runestones (stones carved with runic symbols, usually of a religious, memorial, or magical nature). The woman who makes the beer, Karolina Johansson, wanted the brand identity to be tied in to both the region in which the beer is made and to runestones. The label is printed in five colors, which includes a metallic silver that is used to intensify the look of the granite texture. The rune used on the label is Wynja, which symbolizes happiness, peace, and pleasure. The sign used on the bottle's cap stands for a cultural object or a place that is worth seeing.

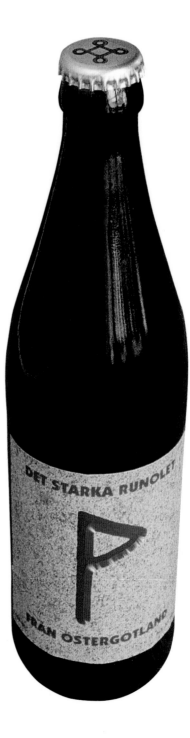

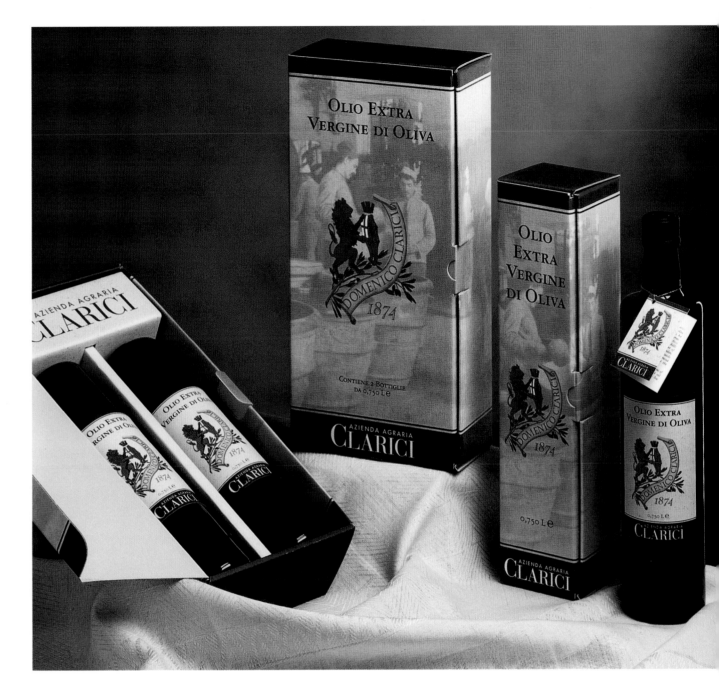

design firm
Studio GT&P di Gianluigi Tobanelli
art director
Gianluigi Tobanelli

Azienda Agraria Clarici/Extra Virgin Olive Oil

Most Italians are quite passionate about the olive oil they use for cooking, and this packaging reflects the need to appeal to that passion. Both the bottle and the boxes are similar to fine wine packaging. The crest on the labels and boxes, as well as the background photograph on the boxes, emphasizes that Azienda Agraria Clarici has been producing Umbrian extra virgin olive oil since 1874.

design firm
Pentagram Design
art director
Paula Scher
designer
Lisa Mazur
photographer
Richard Bachmann

G. H. Bass & Co.

A refined graphic approach signifies Bass's new direction in retailing shoes and apparel. Pentagram reinterpreted an old, undisciplined collection of graphics, advertising, and packaging into a coordinated system of imagery that celebrates Bass's strong New England heritage. The identifying icon refers to Bass's most famous product, the Weejun moccasin, the construction of which was derived from the Native American canoe.

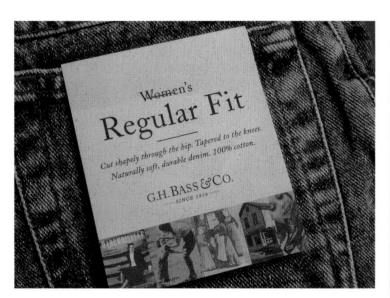

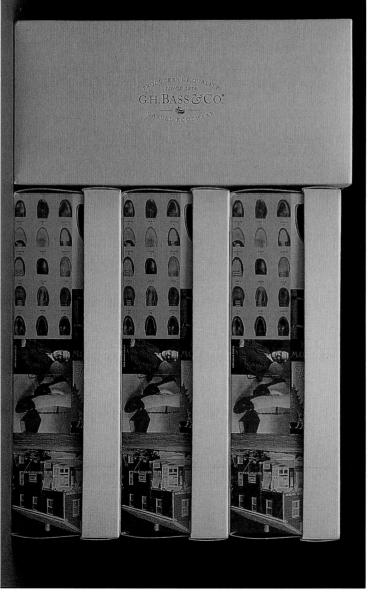

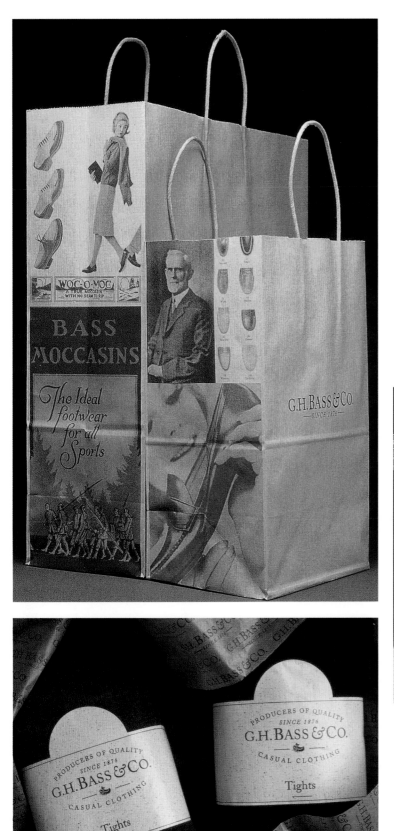

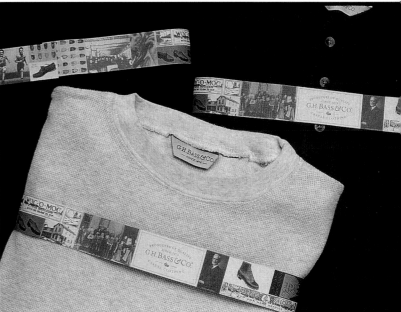

design firm
Turner Duckworth

art directors
David Turner, Bruce Duckworth

designer
Janice Davison

illustrator
Christopher Wormell

Waitrose Soups

The labels designed for this line of soups purposefully avoided the clichéd spoon-and-bowl layouts usually seen on canned soups, and instead relied on bold illustrations.

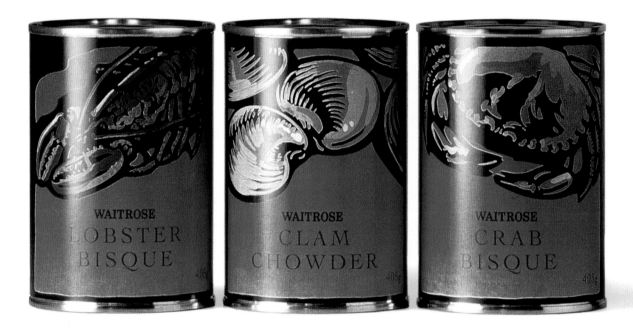

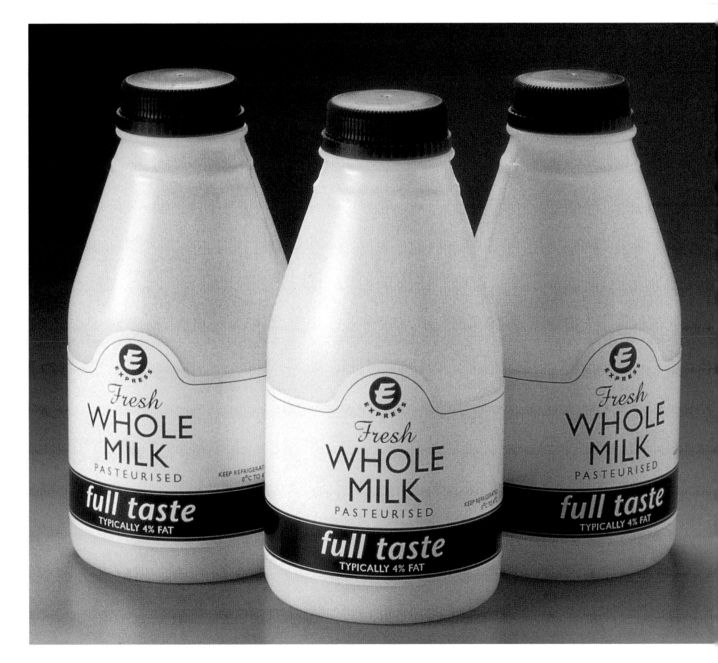

design firm

Minole Tottersfield & Partners

Express Dairies Milk Bottles

Express Dairies wanted a packaging format that would differentiate it from its competitors, be easy to open and reseal, and be instantly recognizable as packaging for fresh milk. Other requirements were that the bottle should be easy to hold when wet, should pour effectively, and that it should fit in a standard retail refrigerator. The design firm drew on the shape of the traditional glass milk bottle (commonly associated with fresh milk), and used standard Snap Cap push-on lids to make the bottles resealable.

design firm
2 Graphic Design
art director
Ole Lund MDD, Jon Nielsen MDD

Carlsberg/Carls Special

The Carls Special label sits on a standard Danish beer bottle, but the designer has managed to create a bright, rather friendly label, where some of Carlsberg's basic graphic elements live in harmony with new elements and new typography.

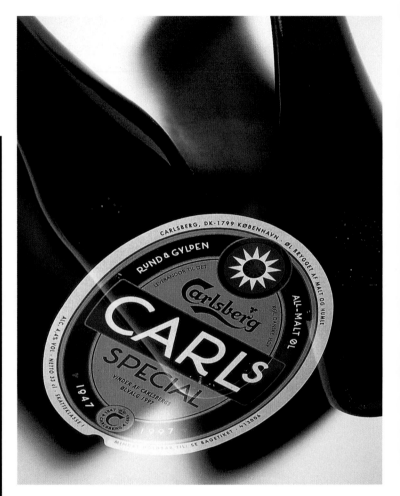

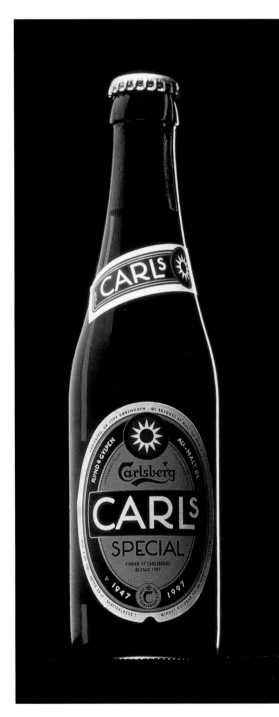

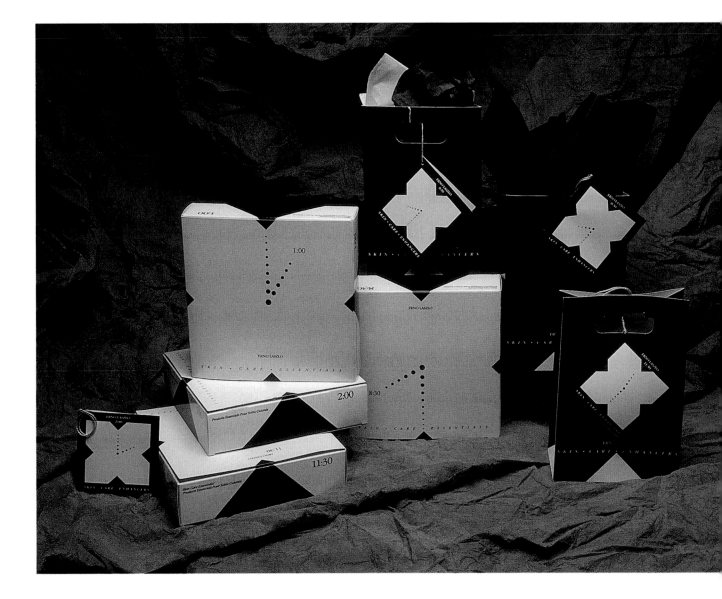

design firm

Tom Fowler, Inc.

art director

Thomas G. Fowler

designer

Thomas G. Fowler

Erno Loszlo Institute

This clock-box packaging was designed for an upscale line of skin-care products. The products are meant to be used at certain times of day, so the clock concept not only identifies the products, but also reminds users of their purpose. This is a simple, yet elegant, one-color solution for packaging.

design firm
Graif Design
art director
Matt Graif
designer
Matt Graif
illustrator
Matt Graif

Rainforest Lemonade

Most ready-to-drink lemonades are packaged in yellow cartons to ensure product recognition. This product uses bold, colorful graphics against a black background to stand out from competitors. A game is printed on the side of the carton in which consumers are encouraged to match the colorful animals printed on the front of the carton with their descriptions.

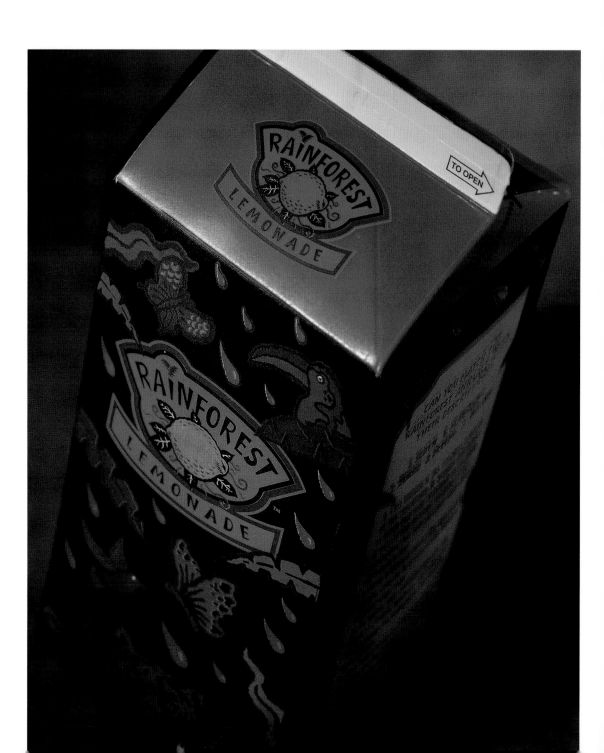

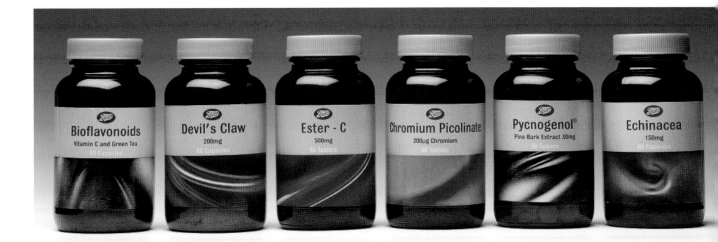

design firm
Roundel
art director
John Bateson
designer
John Bateson
illustrator
Paul Ingle

Boots Specialist Vitamins

The packaging for Boots Specialist Vitamins has to communicate the complex properties of the product: higher potencies of existing vitamins and unusual ingredients. The strong photographic imagery and metallic backgrounds of the labels denote the special nature of the product. The system helps consumers locate the products on the shelf and differentiates them from the more standard vitamins.

design firm
Desgrippes Gobé & Associates
designer
Desgrippes Gobé

Versace Cosmetics

The sleek, elegant lines of these bottles, jars, and compacts reflect the quality of the cosmetics within. The brushed-metal packaging suggests urban sophistication in keeping with the Versace name.

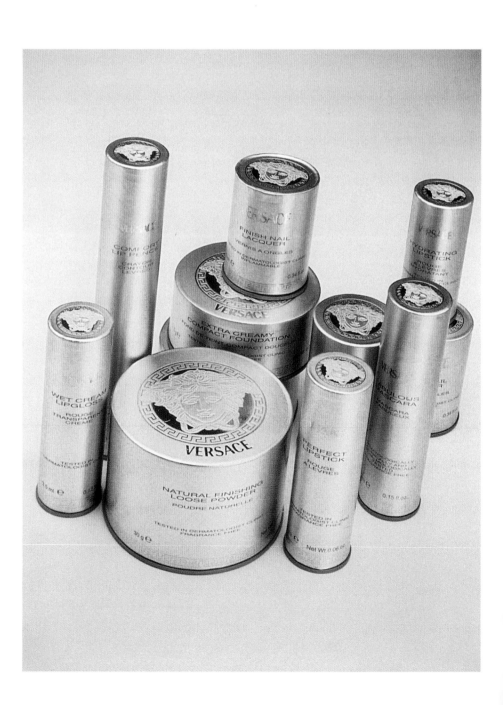

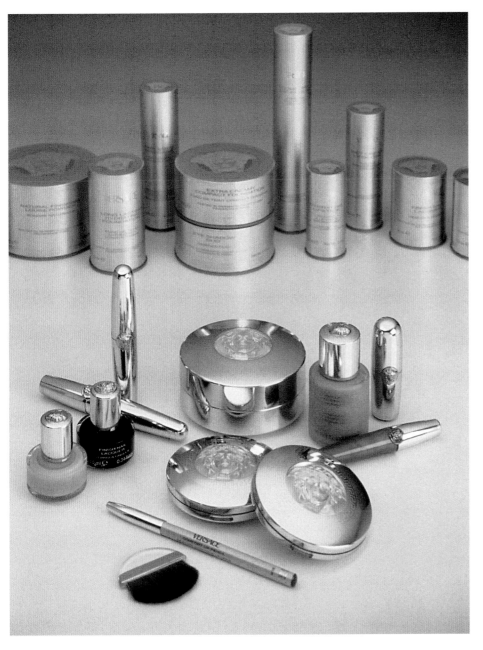

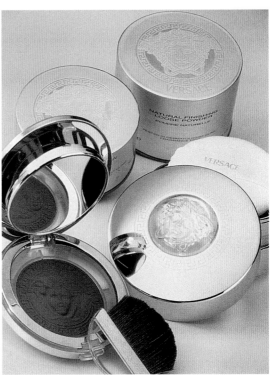

design firm
Coto Partners

Tupperware

Familiar Tupperware products are made more enticing to consumers by packaging them in sets. Artistic photos give the boxes a new look, and product information is reversed out of a black panel to draw attention to it.

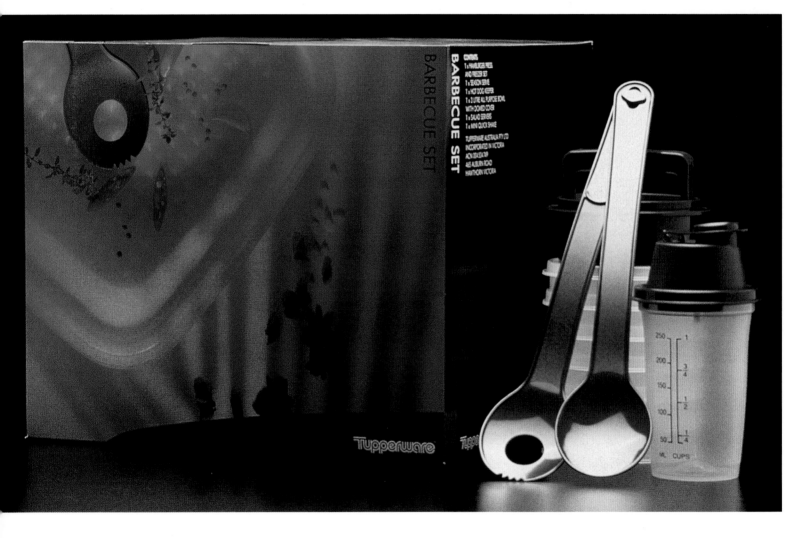

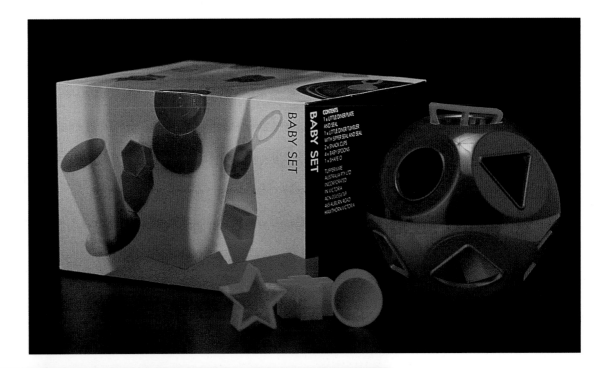

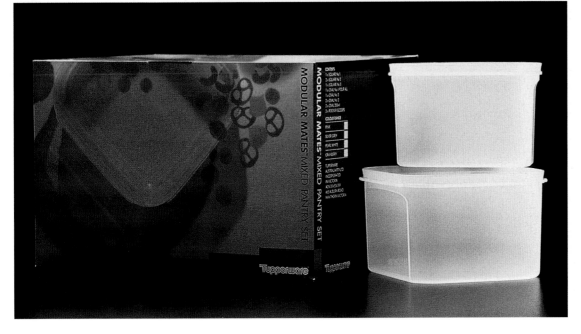

design firm
Maddocks & Company
creative directors
Julio Ledyard, Mary Scott
designers
**Julio Ledyard, Nok Rumpharwon S.,
Ann Utley Moores**

Kanebo, Tokyo/Lunasol

The goal for Lunasol's cosmetics packaging was to define classic beauty in a market that's constantly changing. Based on the elegant luminescence of rose gold, and silver packaging, and extending across packaging, collateral, advertising and in-store merchandising, this line created a new international definition of beauty via an exciting color palette and products that performed—day or night.

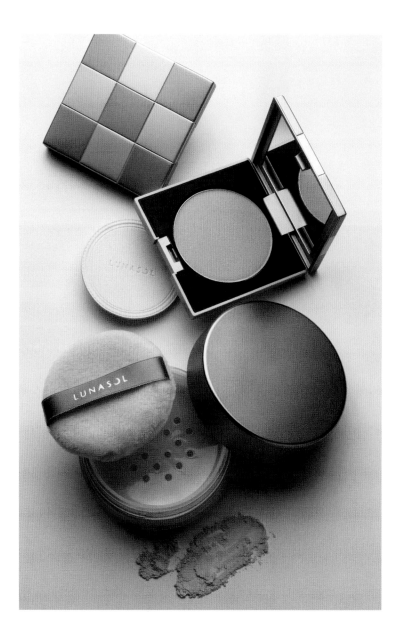

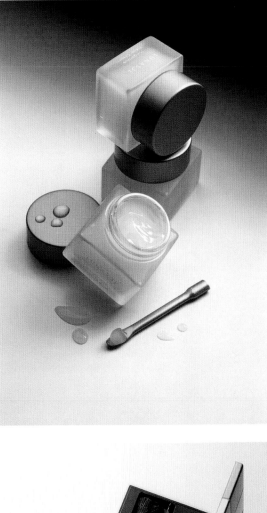

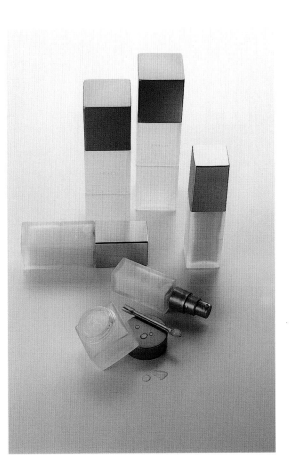

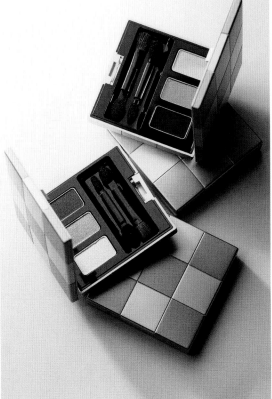

design firm
Pearlfisher

Vin and Sprit/Sundsvall Vodka

The inspiration for both the name and the graphics used for this handcrafted premium vodka are taken from the stone city of Sundsvall, where the vodka is made. The embossed glass bottle and distinctive dragon crest reflect the town's architectural heritage, while the typeface in a central cross represents the layout of the town. A touch of warmth is added by the golden bottle top, which also sets the brand apart from its competitors.

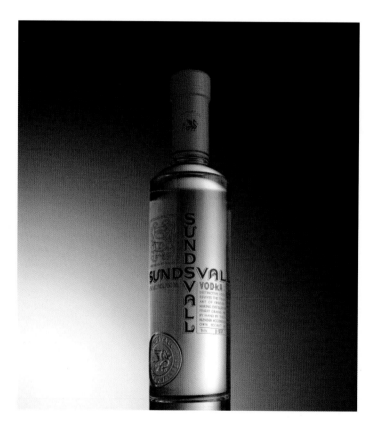

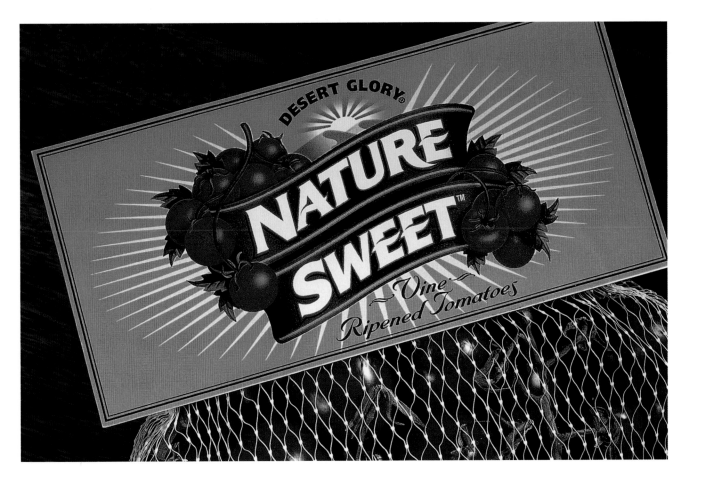

design firm

Cornerstone

art director

Keith A. Steimel

Nature Sweet Tomatoes

Inspired by labels used on produce packaging earlier in the century, this simple label for Nature Sweet Tomatoes uses a subtle burst, reversed out of the bright yellow background to draw the eye to the brand name and product description.

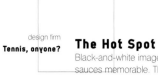

The Hot Spot

Black-and-white images accented with a band of color for the product name make these labels for a variety of hot sauces memorable. The line of sauces, salsas, and glazes, sold in Scandinavia and Germany, currently consists of twenty-six different products—all very hot.

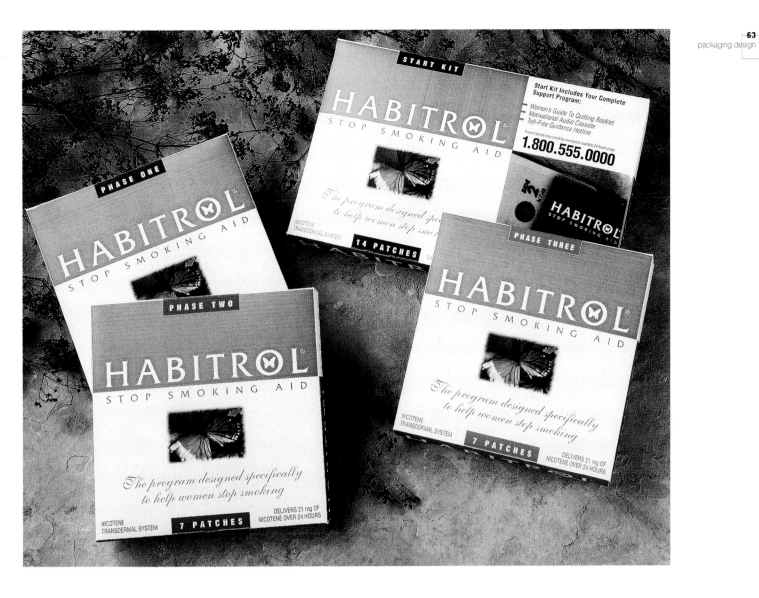

design firm
Michoel Stonord, Inc.

art director
Michael Stonord, Marc C. Fuhrman

Habitrol Smoking-Cessation System

Habitrol is a complete system specifically created to help women stop smoking. The uniquely feminine packaging was designed to compete with the competitors' sterile packaging.

design firm
Bessi Korovil

Star Bene

Star Bene is a firm that produces natural cosmetics products. The company sells customized cosmetics through its Web site. Star Bene makes skin-care products for both men and women. Products for men feature a reddish-brown oak leaf on the labels, while the women's line uses a green leaf on its labels.

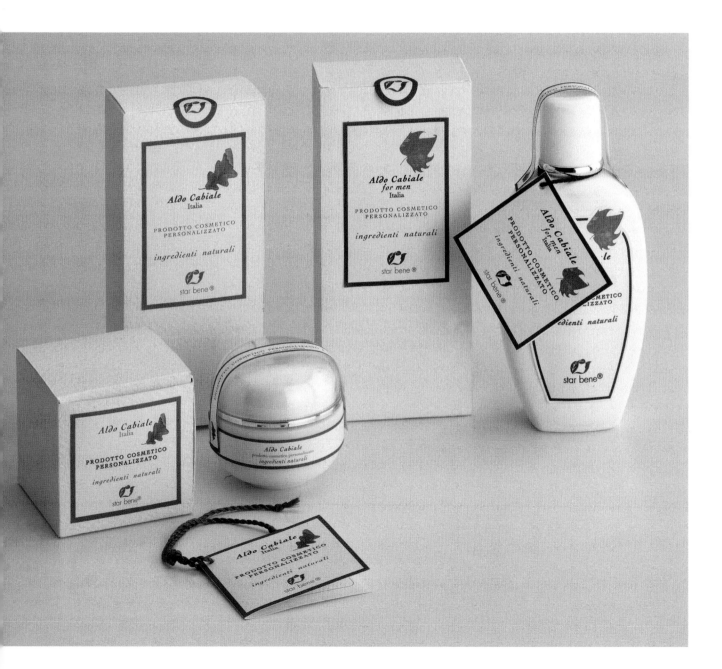

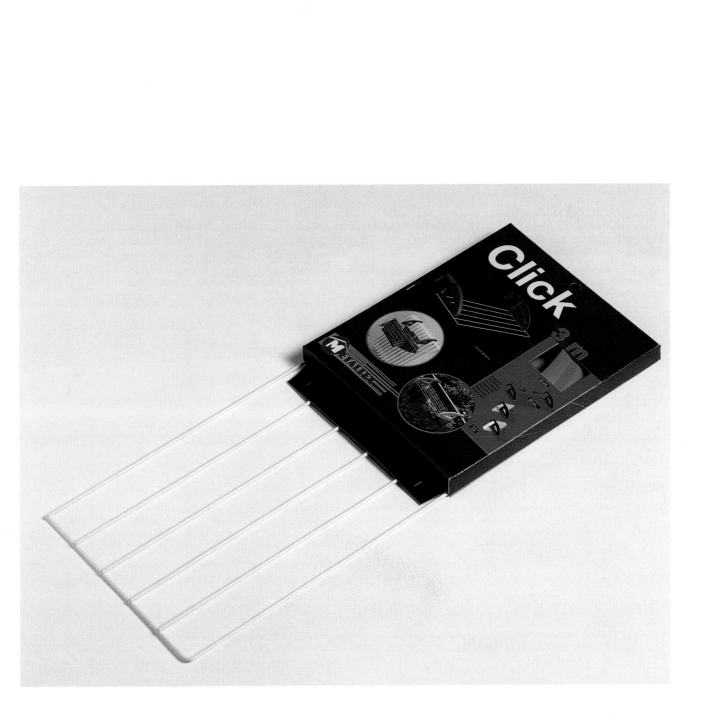

design firm
G/D/S

Metoltex Click

Click is an innovative clothes dryer that can be positioned almost anywhere. The product is packaged in such a way that consumers can examine its materials before they purchase it. Photographs and diagrams on the front of the packaging show the product in use and explain its assembly.

design firm
JOED Design
art director
Edward Rebek
designers
Edward Rebek, Tim Pressley

Red Tomato Italian Restaurant

The printed paper bands "sealing" the lids of the Red Tomato restaurant's jars of gourmet pasta sauces give the products an upscale look. The restaurant's fairly casual logo is subordinate to the other elements on the label, yet is still made prominent and easily recognizable by reversing it out of the color background. The logo is printed in black, red, and green on the restaurant's carryout menu and packaging to garner more attention. The tomato from the logo was lifted out and greatly enlarged to make the packages more visually appealing and instantly recognizable.

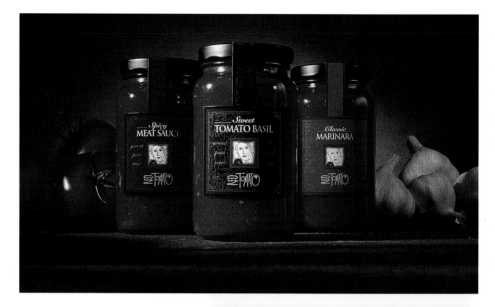

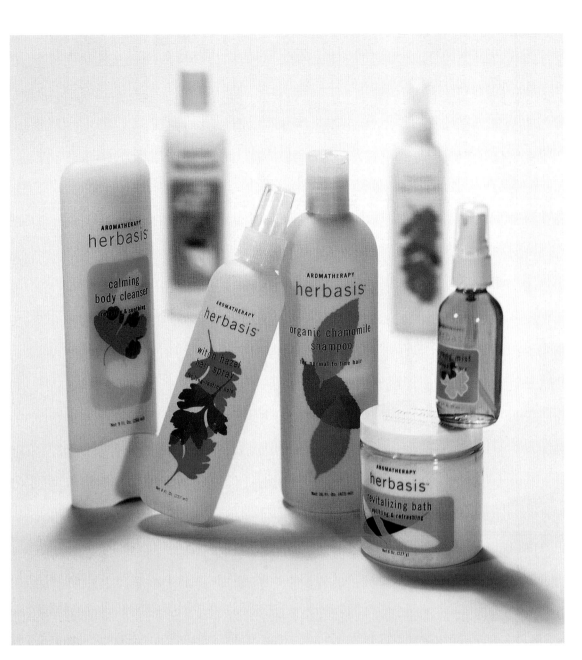

design firm
Design Guys, Inc.

creative director
Steve Sikora

Herbasis

Herbasis is a high-quality aromatherapy hair-and skin-care line developed for Target stores. The packaging is intended to look both natural and modern. Although the product image is quiet and fairly stark, it must live in a self-serve environment and therefore must hold its own with some pretty garish company. The bottles are recyclable and made partially of recycled materials. The design firm broke new ground by insisting the silk screen imprint be done using translucent inks, not standard practice by any means. After extensive testing and client patience they achieved the translucency they were after.

design firm
Desgrippes Gobé & Associates
art director
Phyllis Aragaki

Sears

As part of its continuing effort to promote a "softer side," Sears stores offer their own cosmetics and toiletries lines. The labeling for the Time Out toiletries line uses bright colors and a casual typeface to promote a relaxed attitude; the shapes of the bottles, jars, and soaps are rounded and friendly. The colors and typefaces used on the packaging are carried over to the soaps.

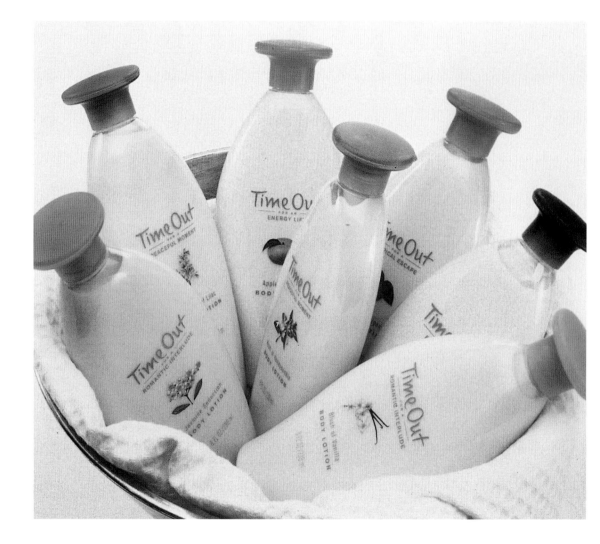

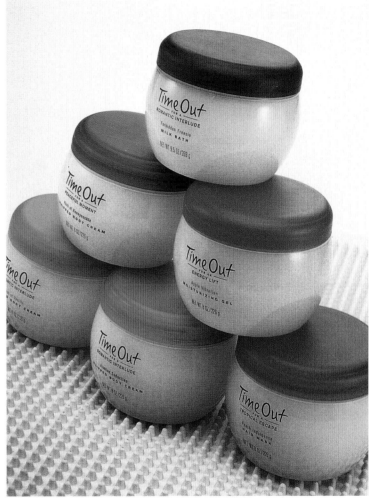

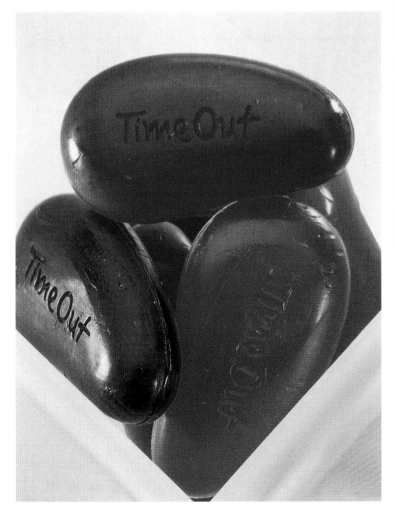

design firm
no.parking
designers
Sabine Lercher, Caterina Romio

Pianegonda Gioielli/I Planetari

Targeted mostly to young people, these silver pendants represent the twelve astrological signs. The cardboard packaging is printed in four different colors tied to the four elements—earth, air, water, and fire—with which the astrological signs are associated. The characteristics of the signs are listed on the back of each package.

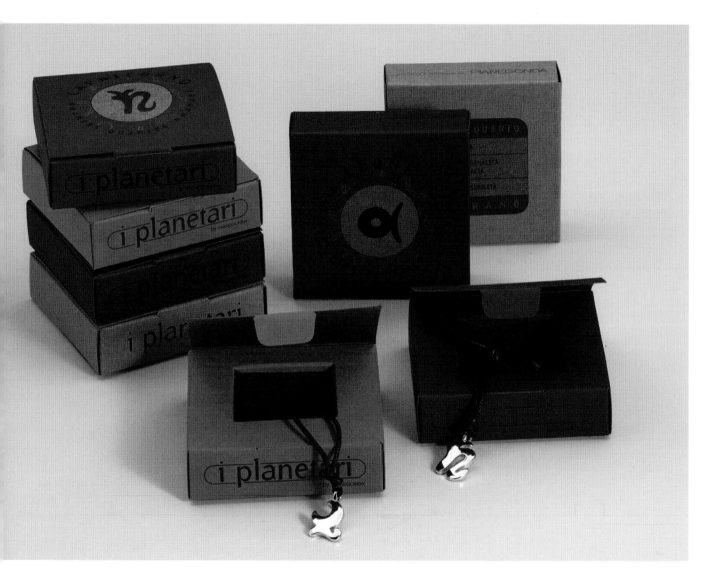

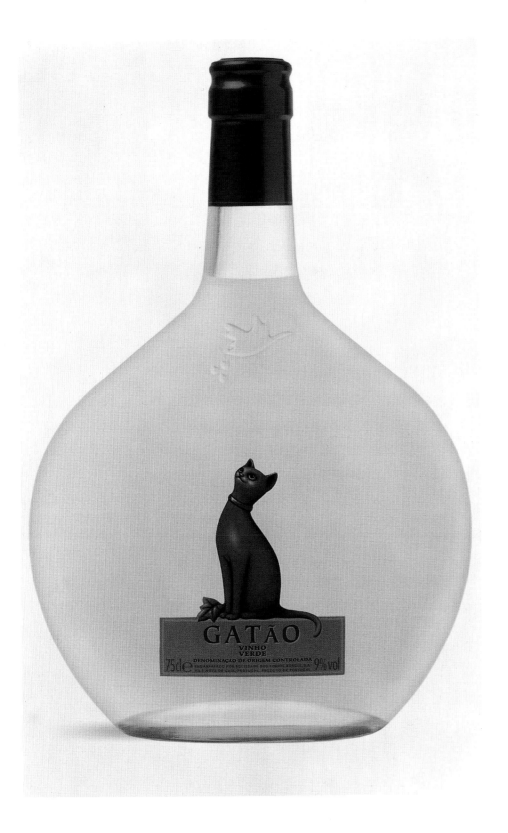

design firm
Blackburn's Design Consultants
designer
Belinda Duggan

Gatão Vinho Verde

Blackburn's was given carte blanche for this project. For the shape of the bottle, they took their inspiration from traditional Portuguese wine bottles, which are round and flat, usually with a handle at the neck. The firm altered this traditional shape a bit to modernize it and to increase the brand's visibility among its many tall competitors. The bird carrying grapes (embossed into the glass) was positioned not only as a focal point for the cat on the label, but also to attract consumer attention.

design firm
Initio, Inc.
creative director
Scott Sample
designer
Derek Sussner

K2 Inline Skates

The firm found that, generally, customers were not aware that K2 made inline skates, but recognized the company for their classic red, white, and blue downhill skis. They used K2's equity in that color combination—along with a simple, bold design—to attract potential customers to the skates. The packaging was designed not only to hold and ship the skates, but also to display the brand's slogan from any vantage point. The packaging for the additional protective gear uses the same color scheme and a similar design, with an additional message to consumers on the bottom of the box.

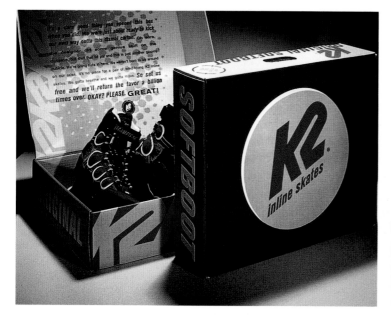

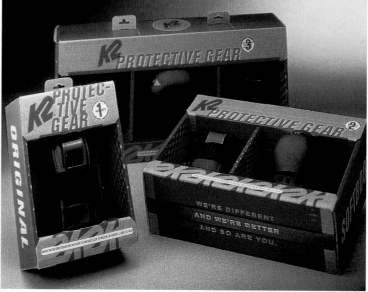

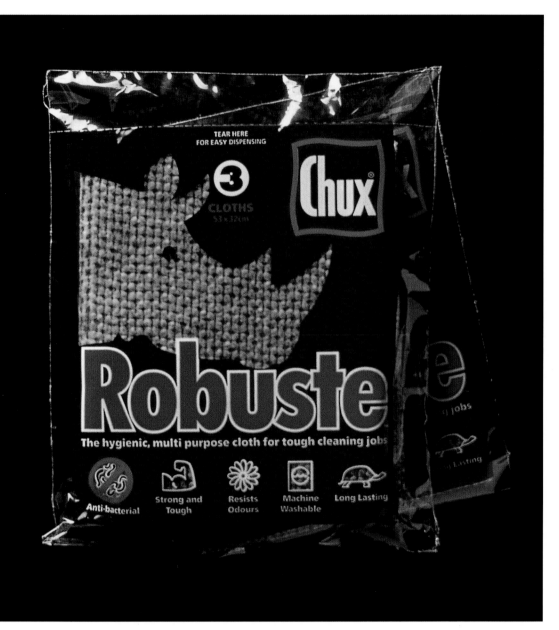

design firm

Coto Partners

National Packs

This new dish towel's main selling point was its strength, so a robust rhinoceros was used on the packaging. The clear area of the packaging lets the weave and texture of the product show through. The rhino graphic was such a strong idea that it was picked up and used by the client's advertising agency in its television campaign.

surprising packaging

Packages must be functional, but they must also have impact in order to stand out in a crowded marketplace. If the product has little or no advertising budget, its packaging may have to serve as a sort of on-the-shelf sales person. Shopping can be an overwhelming visual experience, so an unusual package, or a surprising twist on an established package, can make the customer stop and pick up the product.

Possibly in response to the overwhelming designs of many packages, some designers take a surprisingly minimal approach to package design. Clear acrylic bags and boxes accented with simple type or stickers bearing product names or logos, and plain brown kraft or white stock boxes accented with spots of color can catch consumers unaware amid the aggressively fluorescent packaging of some products.

The public's perception of surprising packaging may change from year to year. Or, it may remain the same. Jean Paul Gaultier's perfume packaging took buyers aback two years ago—the perfume bottle was packaged in a large metal canister and the bottle itself was shaped like a dressmaker's dummy. In the forties and fifties, Schiaparelli's Shocking perfume was contained in a bottle shaped like a dressmaker's dummy and was packaged in a miniature glass bell jar. While packaging materials may change, the concept of shocking or surprising the potential customer remains the same.

design firm
Pentagram Design

art director
Paula Scher

designer
Anke Stohlmann

photographer
David Grimes

Le Parker Meridien

Le Parker Meridien's flagship New York hotel wanted a distinct personality that would prove memorable to guests, ensuring repeat business. To this end, the identity and in-room amenities were designed and packaged to help make the hotel witty, brash, and elegant, something like New York itself.

In-room amenities are elegantly held in a series of long, transparent tubes. These capped containers are filled with unexpected touches like fresh fruit and jelly beans (used for a turn-down on the bed.) A set of test tubes is found in the bathroom, conveniently filled with lotion, shampoo, toothbrush, shower cap, and bath beads.

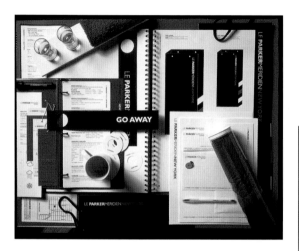

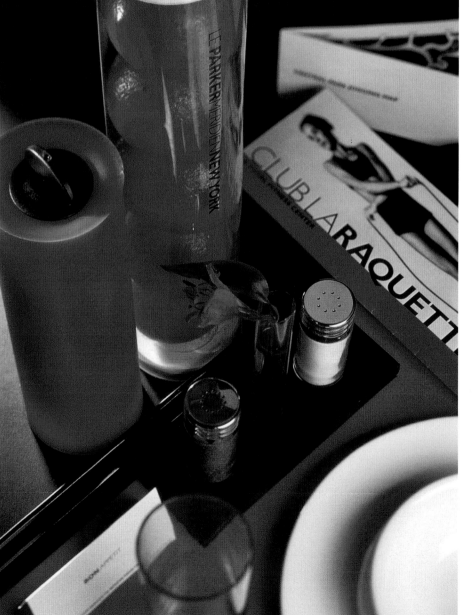

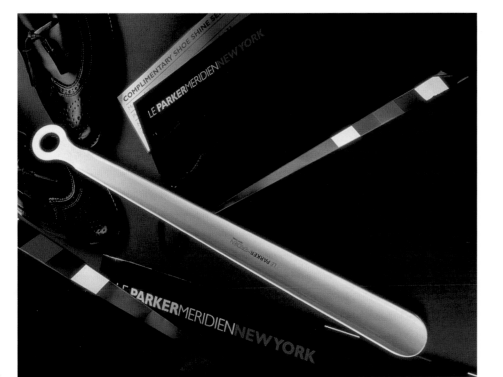

design firm
Mires Design, Inc.

art director
Scott Mires

designer/illustrator
Miguel Perez

photographer
Mike Compos

Jabra EarSet

The Jabra EarSet packaging was designed to compel consumers to pick it up as well as to quickly explain how this breakthrough technology works. Jabra is the industry leader in hands-free communication for cellular and computer users.

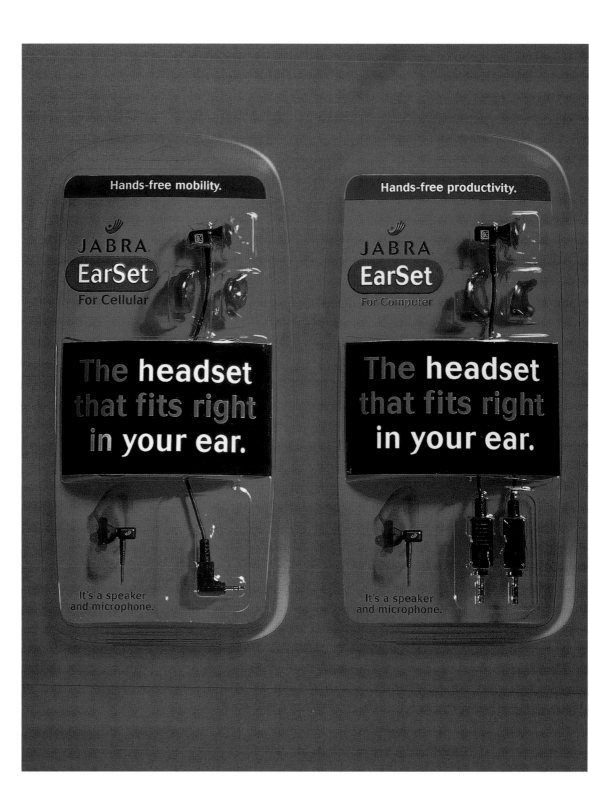

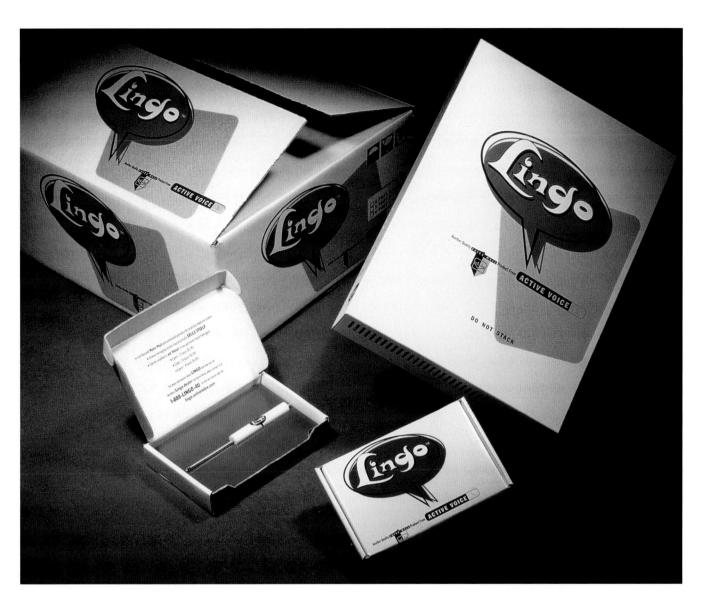

design firm
David Lemley Design
art director
David Lemley
designers
David Lemley, Townyo Lemley

Active Voice/Lingo

Active Voice is a leading provider of voice messaging and call processing. They recognized a niche market that was not being served by the industry—small-to medium-sized businesses that just want simple voice mail. Therefore, Lingo, a retro voice-mail system in a box was created. The advertising, direct mail, and packaging for the system show the consumer just how simple installation is.

design firm
Michael Osborne Design
art director
Michael Osborne

Brown-Forman Beverages Worldwide

A unique bottle structure and a black leather sleeve combine to position this Jack Daniel's Tennessee whiskey as a super-premium spirit in the duty free market. The design of the black and silver box that the bottle is packaged in echoes the design of the bottle itself.

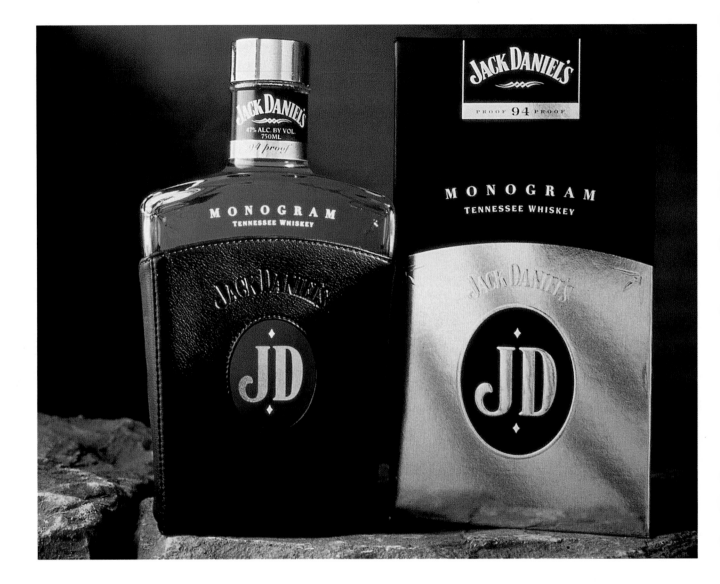

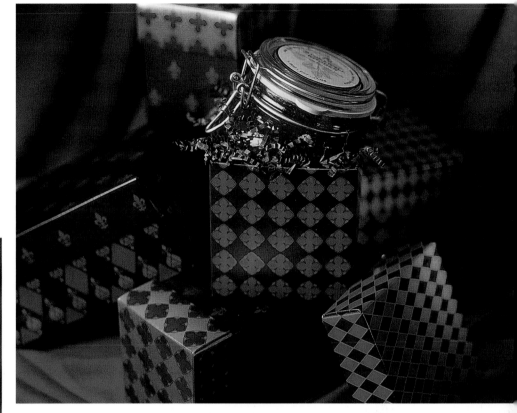

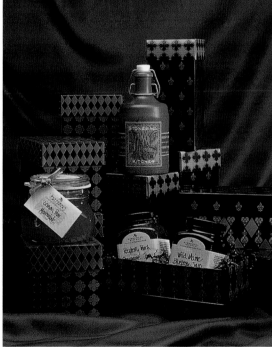

design firm
Leslie Evans Design Associates
art director
Leslie Evans
designers
Leslie Evans, Tom Hubbard, Shoshannah White

Stonewall Kitchen

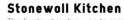

The firm's objective was to reposition a wholesale line of gourmet products into gift items for the holiday season. As an alternative to the usual holiday packaging, the designers used symbols and shapes representative of the Byzantine era to create richly hued patterns. The patterns all mix and match, so that they can be used on lids or bottoms of boxes. This packaging collection provided the consumer with a way to present a gift that is ready to give without having to pack or wrap it.

design firm

Blackburn's Design Consultants

designer

Belinda Duggan

Kendermann Wine

This unique, elegant bottle was created to change popular perceptions of German wines. The "Bend in the River" name was chosen to denote the location of the producer, whose vineyards are located at a bend on the Rhine river. The blue wave shape on the bottle represents the Rhine, while the red dot marks the spot where the grapes for the wine are grown.

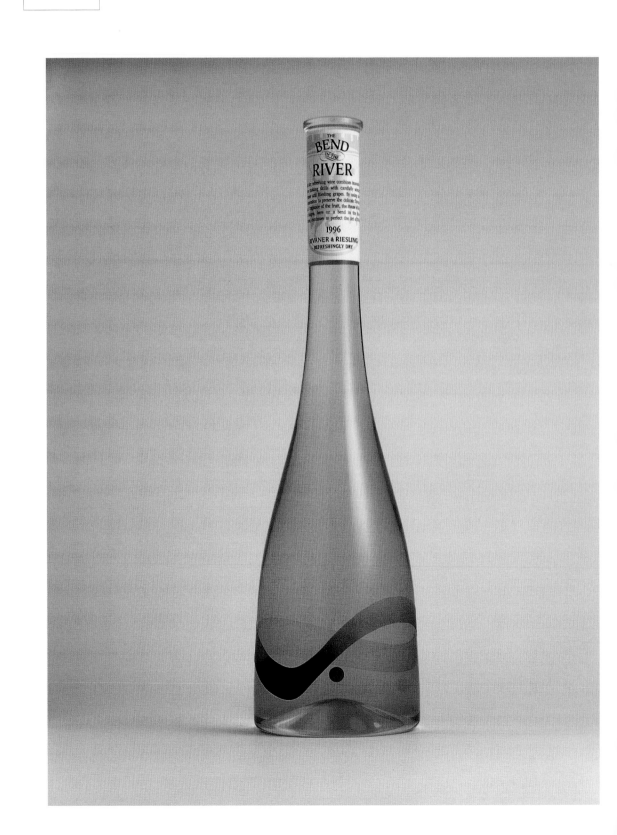

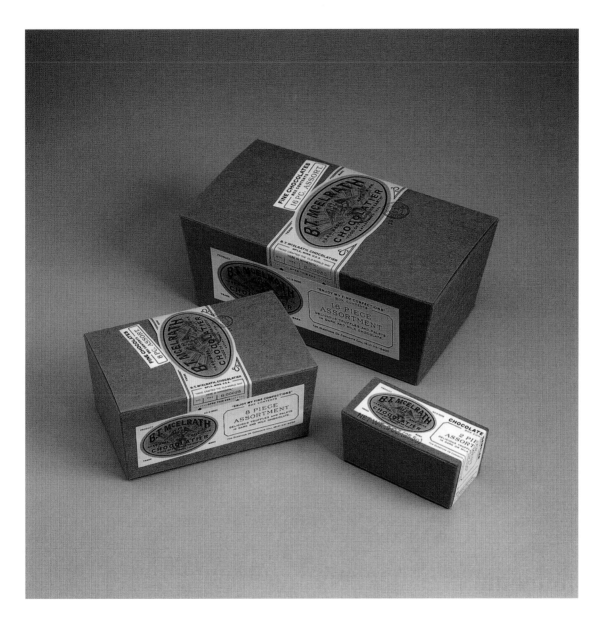

design firm
Studio Flux
art director
John Moes
designers
John Moes, Holly Utech
illustrator
Ken Jacobsen

B. T. McElrath, Chocolatier

B. T. McElrath, Chocolatier creates fine, handmade chocolates using traditional, old-world methods. The logo is derived from the scientific name for chocolate—Theobromine—which means "food of the gods." The look and style of the packaging reflects the quality of the chocolate. A special strap and label system was designed to be applied to recycled stock boxes to meet the client's requirements of economy, flexibility, and environmental sensitivity.

design firm
Lippa Pearce Design Limited
art director
Domenic Lippa
designer
Rachael Dinnis

Soup Opera

Soup shops are fairly new to England, so the design firm needed to create a unique brand identity to entice consumers. Clean type, simple graphics, and the distinctive clear-plastic carrier bags position the store as modern and tasteful. The retail interiors were developed by another firm to complement Lippa Pearce's overall design strategy.

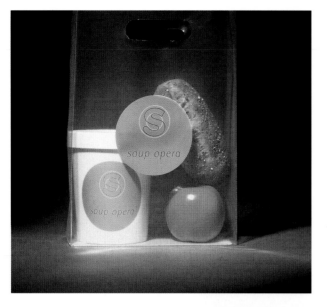

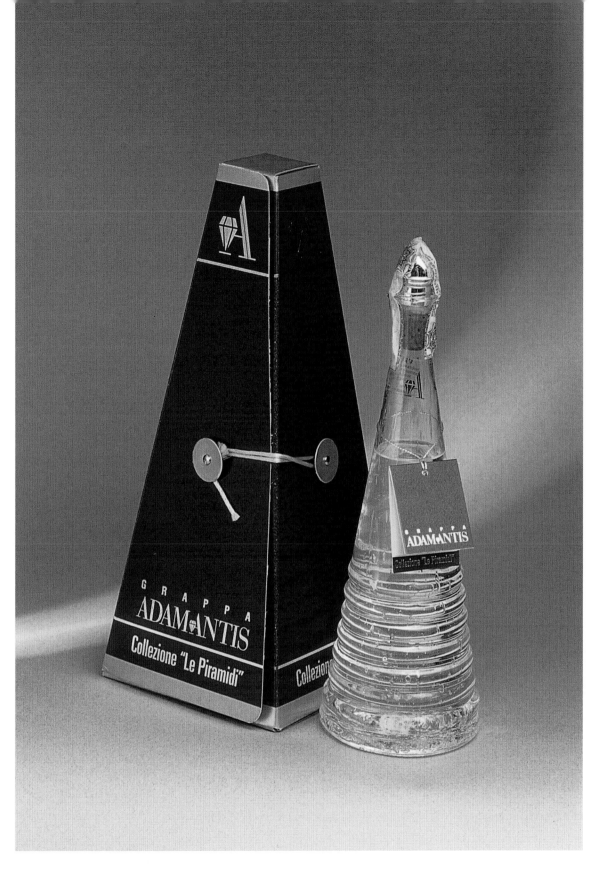

design firm
Studio GT&P di Gianluigi Tobanelli
designer
Gianluigi Tobanelli

Penta Star Spirits

This unusual blown glass bottle houses a special Italian grappa. The pyramid-like box that holds the bottle is printed in blue and silver; the type is hot foil stamped onto the box. The background texture was achieved by using a UV silk screen varnish.

design firm
Device
designer
Rion Hughes

Chad Valley Games

Both of these packaging projects use bold, cartoon-style graphics, type, and colors to catch the eye. The packages for the line of travel games each feature a different mode of transportation (loosely associated with the game inside) on both the box fronts and sides.

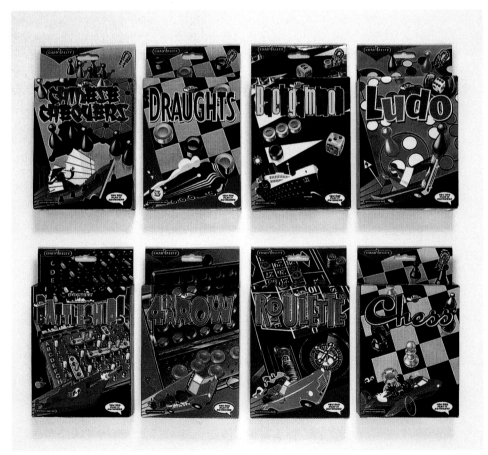

design firm
Lambert Design
art director/designer
Christine Lambert Rasmussen
photographer
James Elliot

Nell Baking Company/Biscuit di Lasca

Nell Baking Company is a small bakery that makes its products by hand. They wanted biscotti packaging that would be inexpensive to manufacture, so the design firm chose to use corrugated paper, rather than a box; labels were printed in different colors for the different flavors of the biscotti. The packages are in two different sizes, and can be produced on an as-needed basis to keep expenses down.

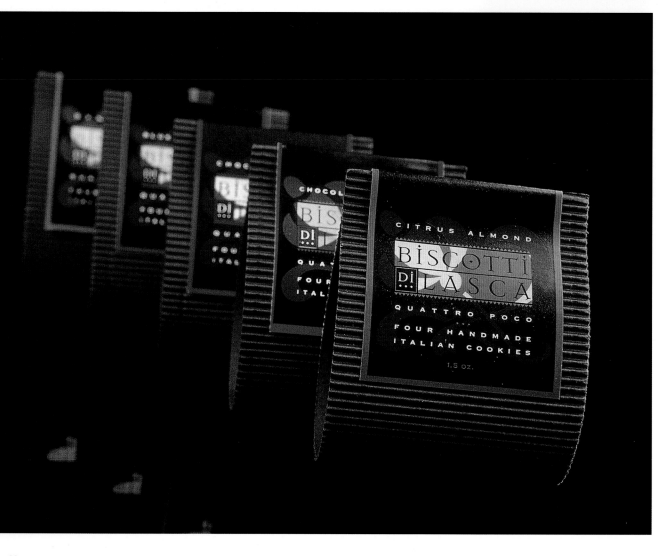

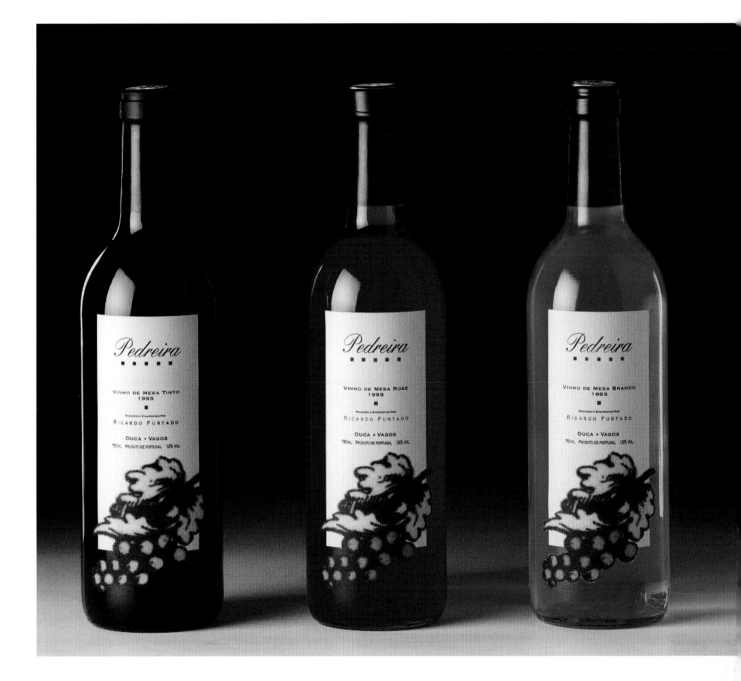

design firm

Nuno Alves

art director/designer

Nuno Alves

Pedreira Wines

Die-cut bunches of grapes accent these labels for a special vintage from a Portuguese wine producer. The grapes on each label are printed in different colors to correspond with the red, white, and rosé varieties for the year's production.

design firm
Groit Design
art director/designer
Matt Groit
illustrator
Matt Groit

Mojo Crunch Condies

Heavy cardboard tubes both protect the coffee-flavored cookies or candies and make them easy to display in a retail environment. The package labels are color coded for the different flavored treats—green is used for the decaffeinated offering, as is typical for decaf coffees.

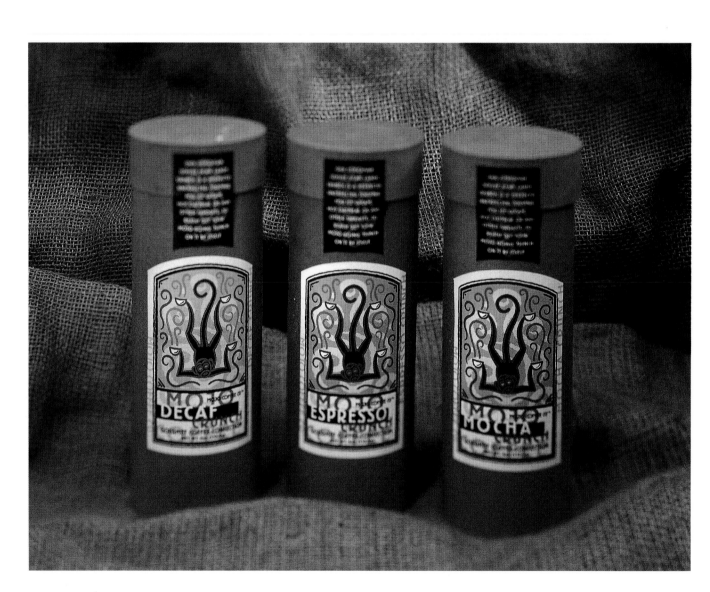

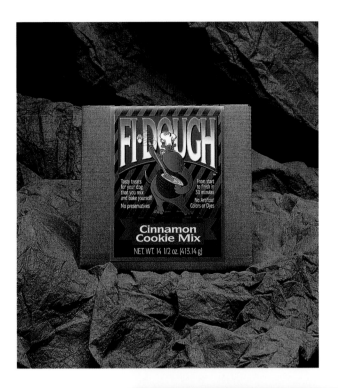

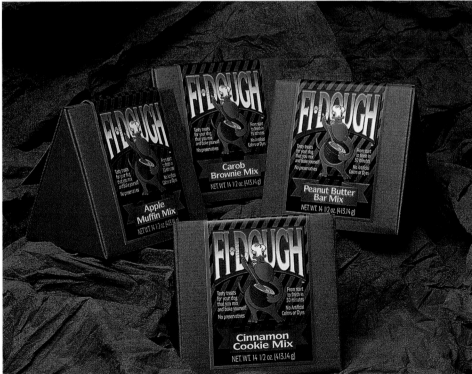

design firm
Tom Fowler, Inc.
art director
Thomas G. Fowler
designers
Thomas G. Fowler, Elizabeth P. Ball

Fi-Dough Dog Treats

This unique line of ready-to-make dog treats warranted an unusual triangular packaging treatment. The logo shows a playful dog character mixing up a batch of dog treats. The logo plays an important roll in the overall label graphics, creating an inviting and fun-loving package that pops off the shelf.

design firm
Korn Design
designers
Denise Korn, Javier Cortés

FKIA

FKIA, a Boston-based innovative product-design and fabrication company, needed packaging to launch an extension of their gifts and home-products line. Korn Design paired stencil black, bold, blocky typography with a keyed-up palette of bright, clean accent colors, reflecting the color of the products themselves.

The designers' goal was to expose as much of the product as possible and attain name recognition for FKIA. A translucent polypropylene plastic was selected that would provide support for each product while allowing the colored resin bases to appear through the openings.

Due to a slim budget, the firm devised a sticker system to avoid printing the actual packaging. These stickers were printed onto clear stock, allowing light to pass through both the package and the labels. Because the primary type is a rich black, it is very readable and has a bold shelf presence. Some printed inserts were also designed for the picture frames and picture holders where stickers were not effective.

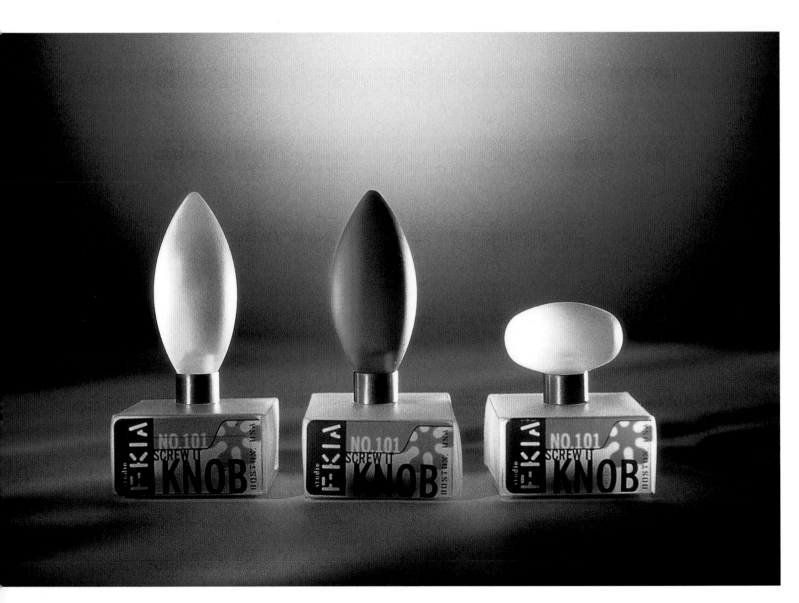

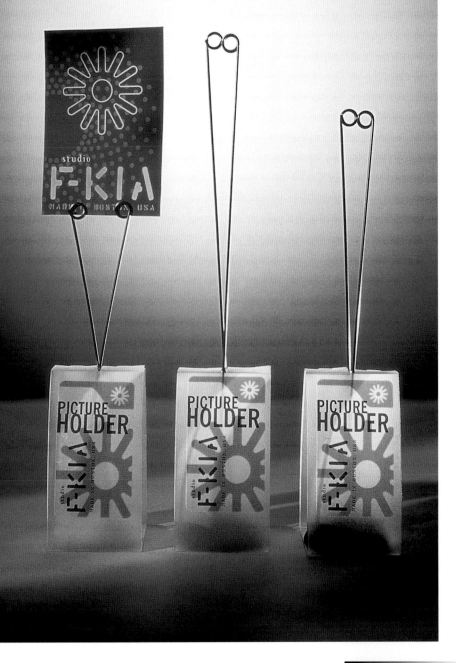

design firm
Minale Tottersfield & Partners

Exté Underwear

This futuristic underwear packaging was designed for an Italian fashion house. The packaging is suitable for men's or women's products. It is kidney shaped and uses a metallic silver lid made from laminated aluminum foil, embossed with the company logo, which peels off to reveal a transparent tray in which the product sits. The package's shape is deliberately soft and amorphous, its contours resembling those of the human body.

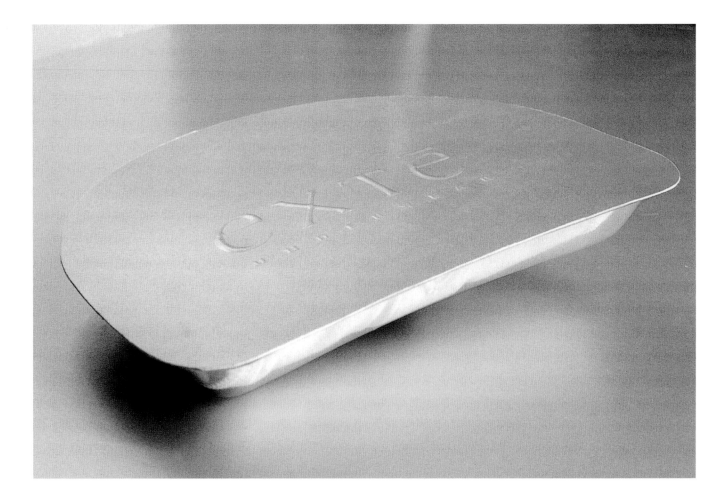

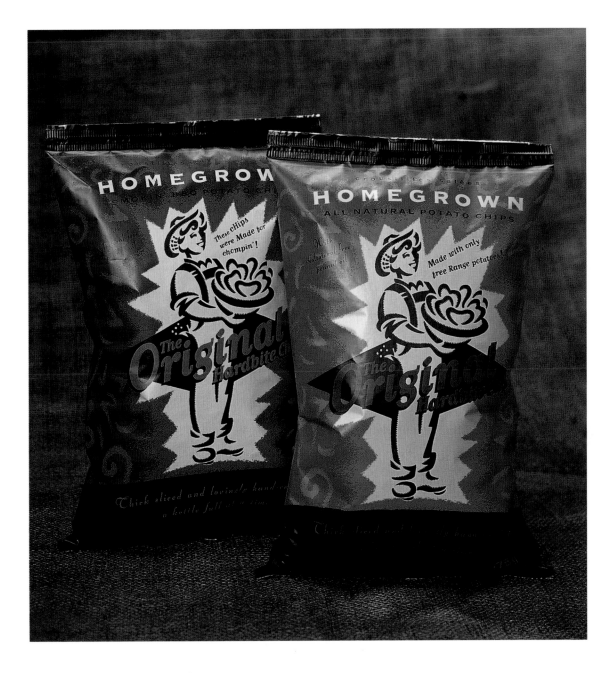

design firm
Thumbnail Productions, Inc.

art director
Rik Klingle

designers
Valerie Turnbull, Judy Austin

illustrator
Randall Watson

Homegrown Foods/Hardbite Potato Chips

Thumbnail Productions needed to create instant history for this new contender in the premium potato chip market. They wanted the bag to seem familiar—like a brand customers might have known in childhood—only with updated packaging. So, a character was created as a spokesperson for the brand; his proclamations include "Don't settle for chip imitations" and "These chips were made for chompin' ." These sayings were rotated during the print run so that the bags on the shelves show a variety of sayings, encouraging consumers to take a closer look.

design firm
RTR Packaging & Design
art director
Ron Roznick
designers
Maureen Gillespie, Ron Roznick
production managers
Marty Todd (Condé Nast)

Condé Nast House & Garden Magazine

Magazines aren't usually packaged, but Condé Nast's House & Garden magazine's luxury issue deserved this extravagant touch. The metallic ink, organza ribbon, and "It's all about luxury" tag let readers know that they're holding a special issue.

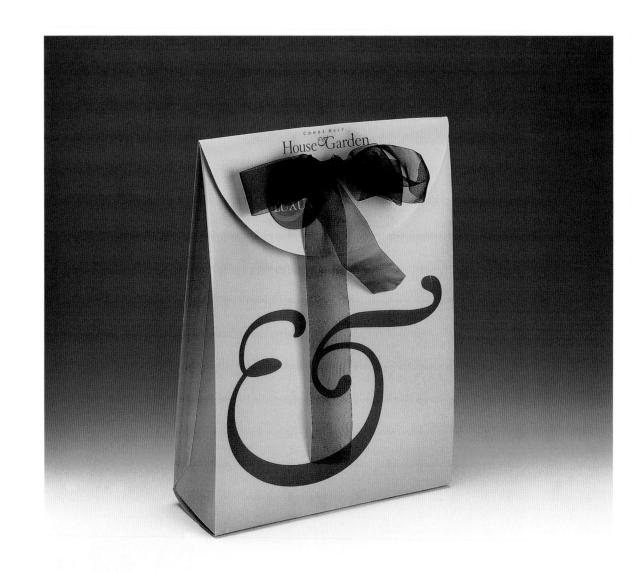

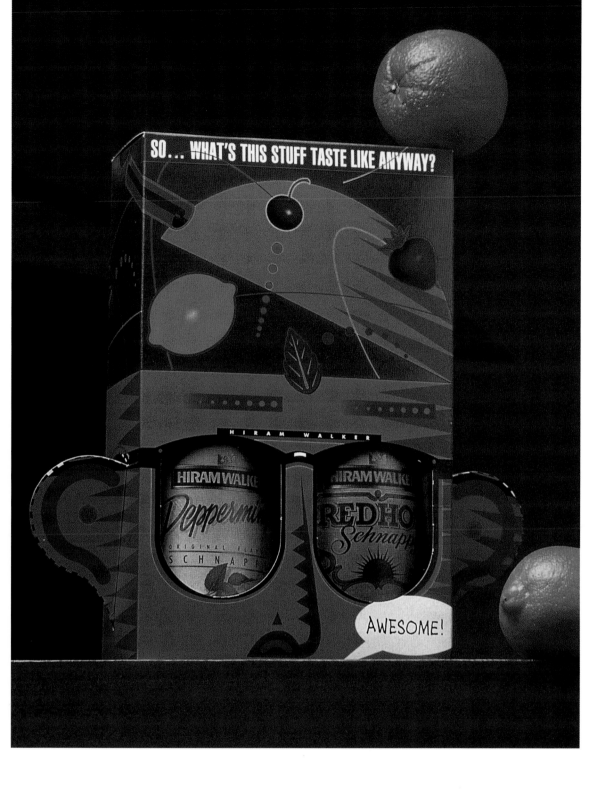

design firm
Thorp Did It
art directors
Charles Drummond, Rick Thorp
designer
Rick Thorp
illustrator
Steve Lyons

Hiram Walker

This package is meant to serve as a small billboard, not as just a product box. These "billboards" had three objectives. First, they were designed to help Hiram Walker gain a market share by helping the consumer differentiate between Hiram Walker liqueurs and other brands. Second, they were intended to entice the customer who was already looking for a liqueur to buy an additional bottle or two to experiment with different flavors. Third, they were designed to attract new customers who aren't normally liqueur purchasers. The ears on the side panel are perforated to allow the retailer to pop them out for display purposes.

design firm

United Distillers/Vitners In-house

art directors

Arlene Gerwin, Steve Wollet

Smirnoff

The Smirnoff nutcracker decanter is an innovative package modeled after a familiar holiday icon—a nutcracker. Standing at attention, this finely detailed bottle is an official soldier complete with facial features, cuff buttons, and boots. Two labels provide the uniform decoration—including one adorning the cap.

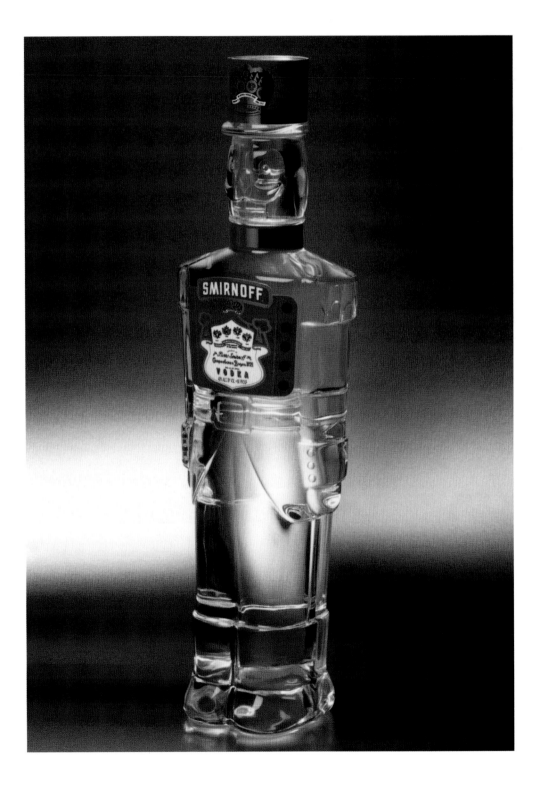

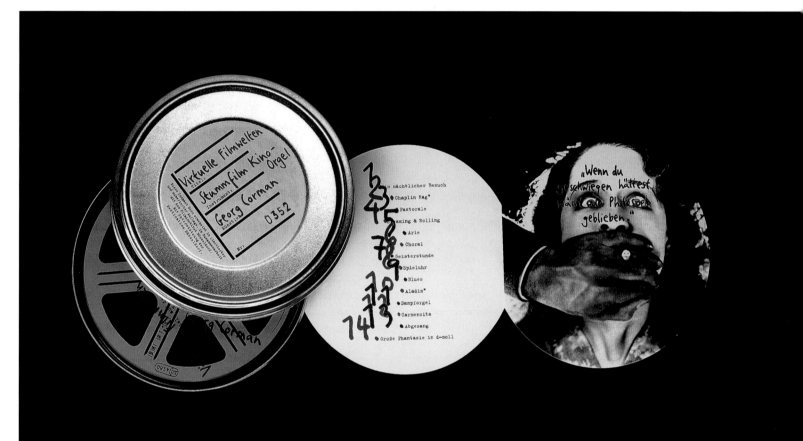

design firm

Fons M. Hickmann

designer

Fons Hickmann

Mikor Musik

The unusual packaging for this CD—a film canister—is appropriate as the content is music arranged on a silent movie organ. The CD's title is *Virtuelle Filmwelten* (Virtual Movieworlds); a round booklet is included in the package.

design firm
Gregory Thomas & Associates
art director
Gregory Thomas
designer
Scott Motz

Seagram's Canadian Club
The graphics had to sell the bottle for this new citrus-flavored beverage, so the design firm went with edgy type, motion lines, and bold colors. The design wraps around the entire bottle—still somewhat unusual for drinks in this category

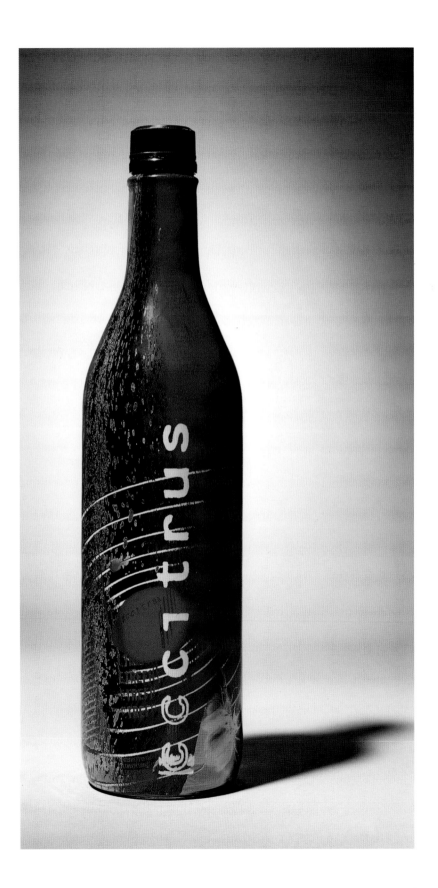

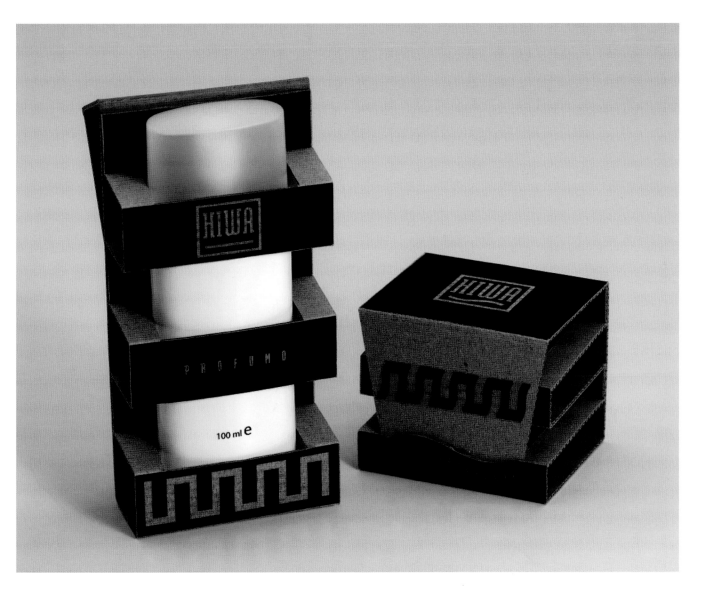

design firm
no.parking
designers
Sabine Lercher, Caterina Romio

Hiwa Cosmetics

This packaging for a new cosmetics line was designed both to showcase the products and to work as a display. The bold design is silk-screened in black on sturdy cardboard.

design firm

no.porking

designers

Sobine Lercher, Coterino Romio

AKO Aftershove

The black stripes printed at the side of these unusual packages add depth to the design. To take the effect even further, the stripes are die cut and folded to pop out from the body of the box. These razor-like edges underscore the purpose of the product.

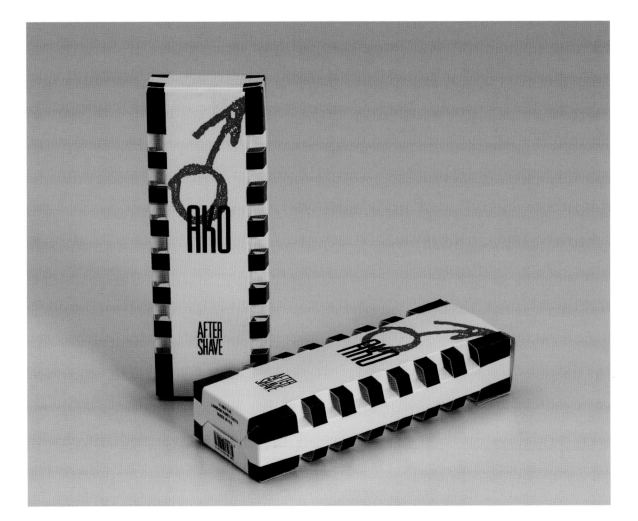

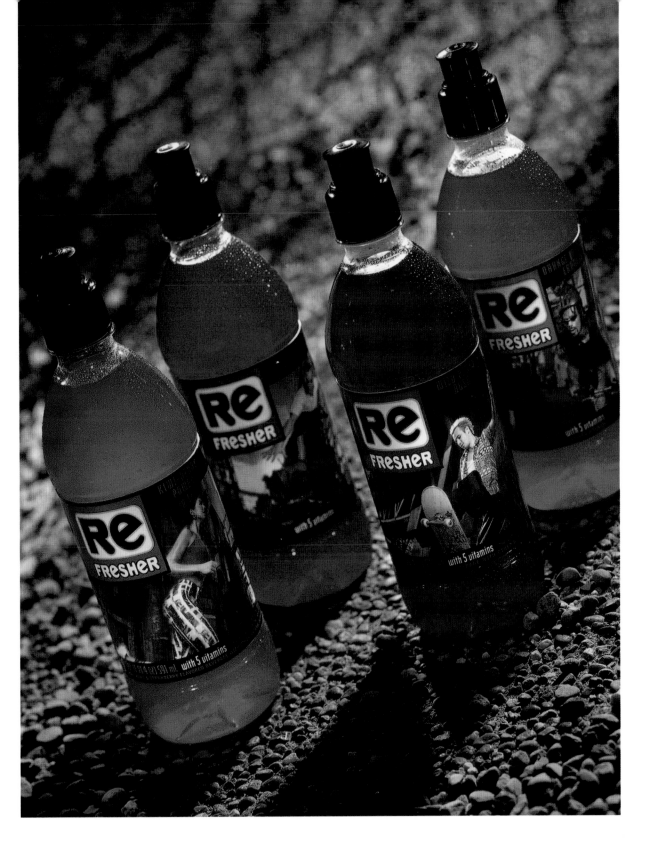

design firm
Karacters Design Group
creative director
Maria Kennedy
art director/designer
Matthew Clark
photographer
Waldy Martens Photography

Refresher Fruit Beverage

This vitamin-fortified alternative fruit drink uses a clear bottle as a stage to show off the Day-Glo colors of the various product flavors. The labels' duotone photographs represent the type of consumer the beverage appeals to.

design firm
Karacters Design Group
creative director
Maria Kennedy
art director/designer
Matthew Clark

Clearly Canadian O + 2

The blue tint of this water bottle not only makes the product look more substantial, it implies sky or air in order to underscore the benefit of the superoxygenated water. The shape of the bottle plays off this theme as well—it is reminiscent of an oxygen tank.

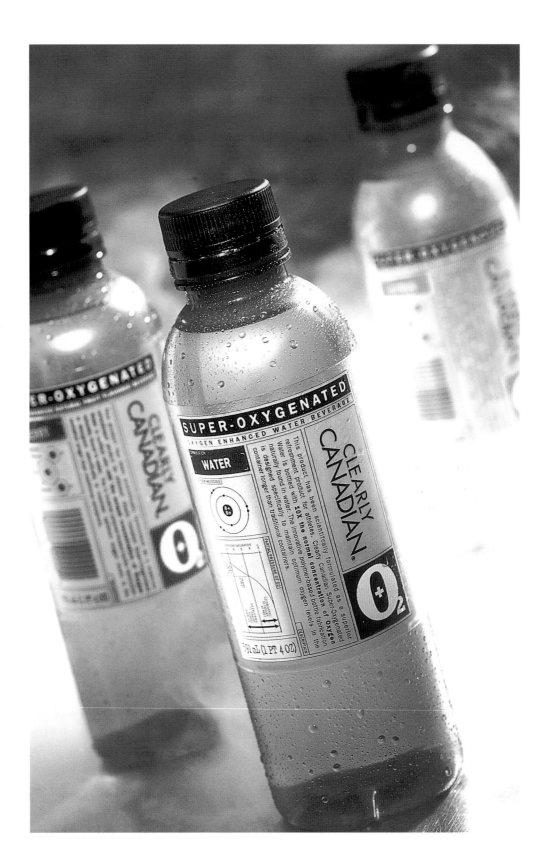

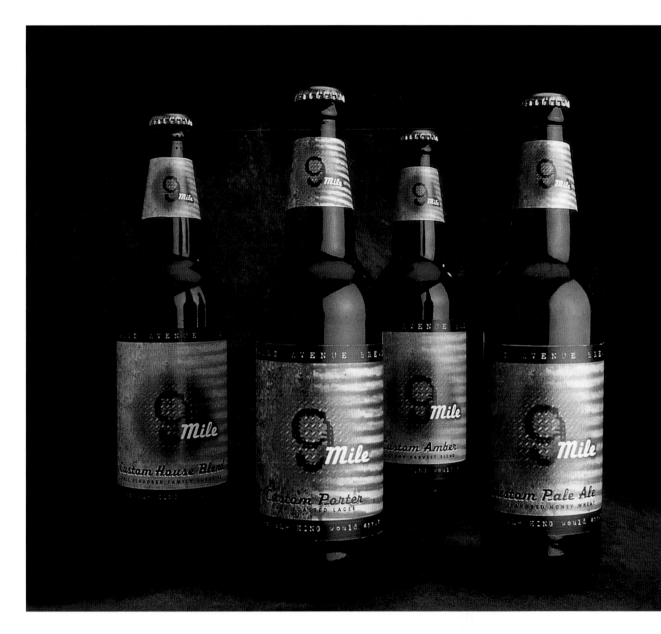

design firm
Pat Carney Studio
art director/designer
Lizabeth Montgomery

9 Mile Beer

These unusual beer labels forgo the usual gold, green, and white or red, blue, and silver color schemes in favor of a different simple color used for each type of beer in the line—pale ale, amber, porter, and so on.

design firm
Desgrippes Gobé & Associates
art director
Lori Yik
designer
Bryn Spohr

Guess

The packaging designed for Guess' holiday items appears to be almost nonexistent. Simple, clear acrylic boxes, lids, and pouches let the merchandise show through the packaging to entice buyers. Such an approach is more complex than it looks, as the designers had to be sure the white Guess lettering printed on the packages would position exactly over the product inside so that it could be read.

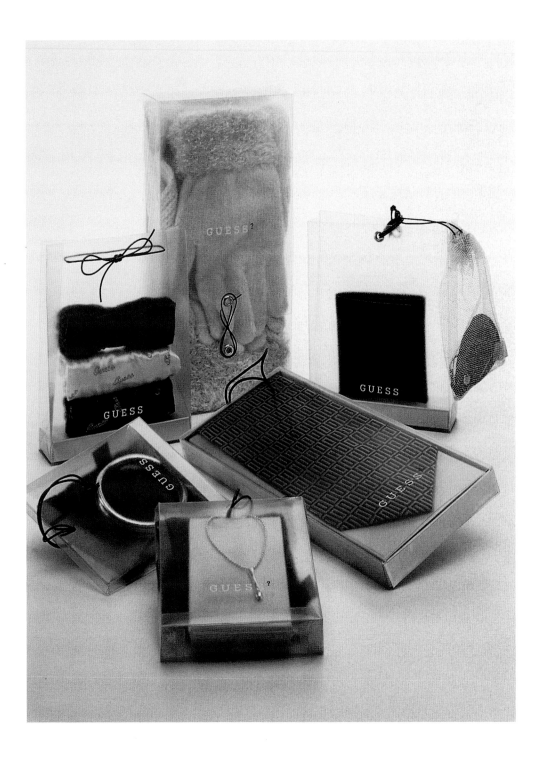

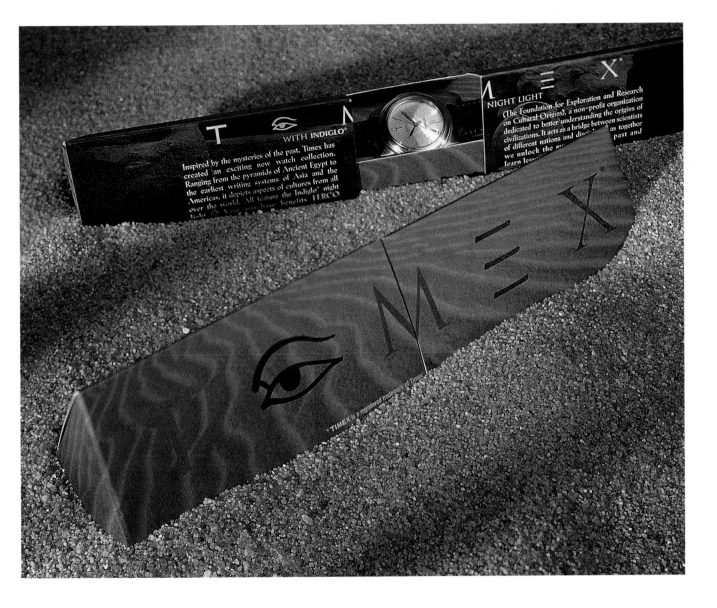

design firm
Leslie Evans Design Associates
art director
Leslie Evans
designers
Leslie Evans, Tom Hubbard, Frank Nichols

Timex

Timex wanted to launch a new watch line—Antiquities, Watches of the Ancient World—and they needed packaging to complement the product. Working with the antiquities theme, the design firm created unusual packaging for the new line by designing the pyramid-shaped box. The boxes are enhanced by four-color printed images that speak to the theme of the watch line. Each image depicts a different culture from an ancient civilization.

design firm
Osoxile, S.L.

Museu Nacional d'Art de Catalunya

The firm was assigned the task of researching and creating several products based on a collection of Gothic art. They found a detailed view in a section of an altarpiece showing two women washing their hands, which led them to create a soap packaged in a box decorated with a detail of the art. The soap is stamped with an image of a mermaid found on a palace ceiling beam.

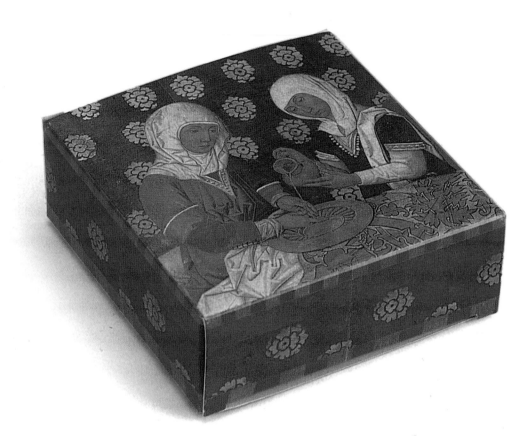

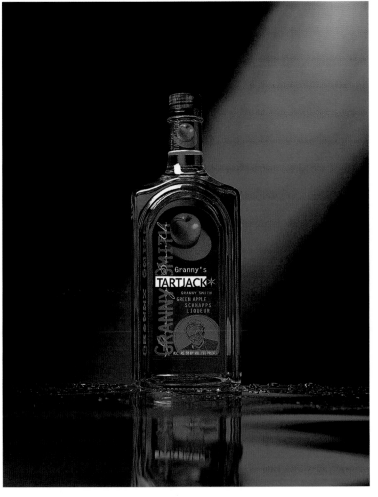

design firm

Port Miollo Associates

art director

Rob Swon

Seagram's Granny's Tartjack

Designed to attract Generation X schnapps consumers, Granny's Tartjack uses humorous imagery, brilliant color, and an unusual type treatment to get attention on crowded store shelves. The vibrant green label on the back shows through the clear glass of the bottle, the clear liqueur, and the clear film label on the front of the bottle.

design firm

Novodesign

Telecel/Vitamina R

Aimed at 16- to 25-year-olds, the packaging for this cellular telephone incorporates design characteristics from the primary line developed for Telecel, the largest non-government owned telecommunications company in Portugal. The all-in-one package contains the mobile phone, a preactivated card, and other items the customer needs to put the phone to immediate use.

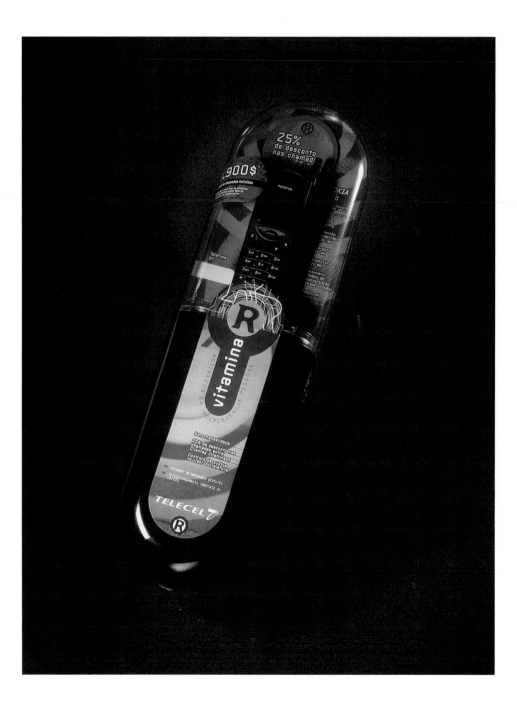

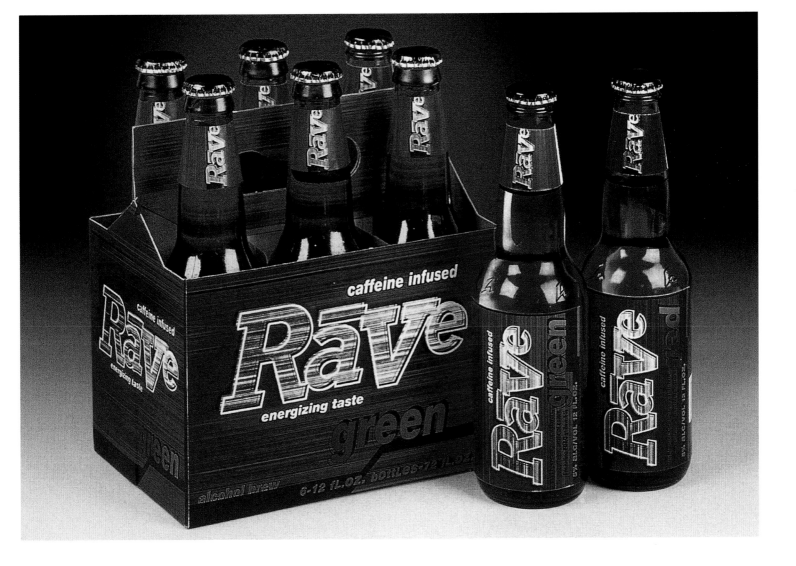

design firm
Port Miollo Associotes

Rove

A streaked background implies energy and motion on the labels and packaging for this caffeine-infused alcohol beverage. A similar streaked treatment is used on the type.

design firm
Turner Duckworth
art directors
David Turner, Bruce Duckworth
designers
David Turner, Allen Roulet
typographer
Bob Celiz

Sun Devil

This packaging is a tongue-in-cheek homage to mid twentieth-century California crate labels that used quirky characters to advertise fruit brands. Aimed at adults with a sense of fun, this alcohol-and-lemon brew is a refreshing alternative to beer. The packaging was adapted for berry and orange flavors.

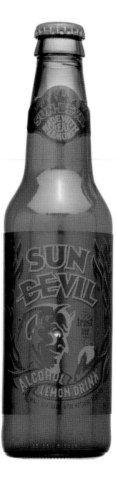

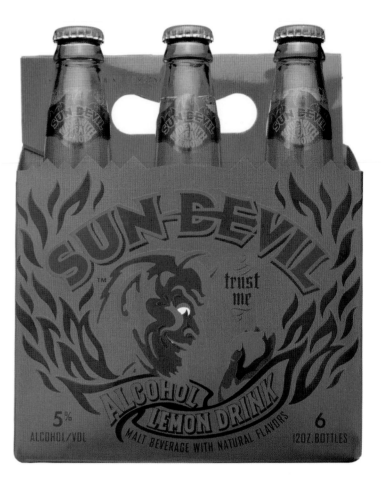

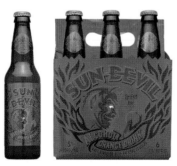

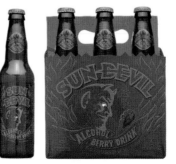

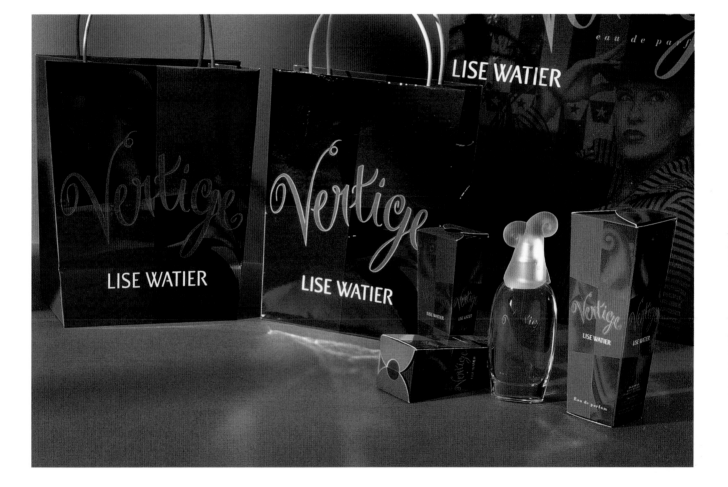

design firm
Goodhue & Associés
project director
Luc Goodhue
creative director
Lise Charbonneau
art director
Nathalie Houde
designers
Nicole Bouchard, Dany Degrâce, Josée Barsalo

Lise Watier Cosmétiques/Vertige by Lise Watier

The package design lends an ultra-feminine, colorful identity to the product. A remarkable stopper tops a simple bottle: a flower/shell hybrid, reflecting the fragrance's dual floral/marine character. This stands out from the current asexual, pared-down look of perfumes geared toward the youth market.

design firm
Seasonal Specialties, LLC

creative director
Jennifer Sheeler

art director
Lisa Milan

illustrator
Specer Jones, FPG

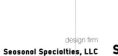

Shopko/Holiday Trim

These holiday ornament boxes will certainly stand out from their red-and-green competition. Here, the ornaments are packaged in sets of jeweled gold and arctic (blue and silver) colors. Each package uses a photo of the product inside, set against a white background.

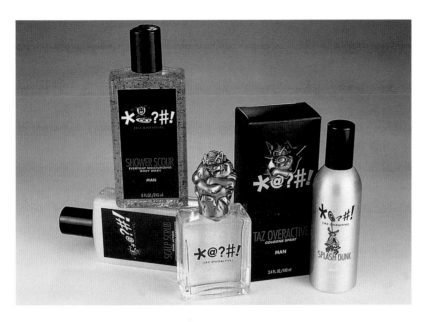

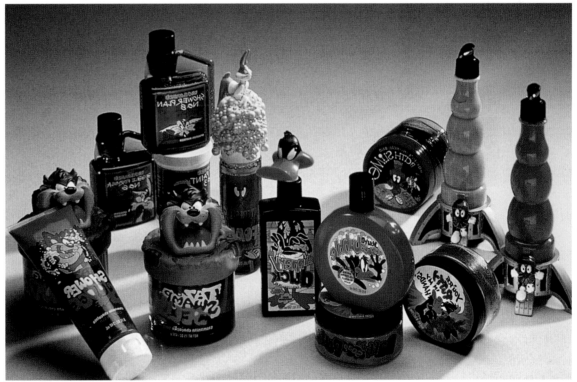

design firm
Maddocks & Company
creative directors
Julio Ledyard, Mary Scott
designers
Julio Ledyard, Catherine Cedillo, Amy Hershman

Warner Brothers Retail Line

Maddocks developed products and package concepts around favorite characters such as Taz, Tweety, and Marvin the Martian. True to the spirit of Warner Brothers cartoons, characters and products interact in a series of spoofs, gags, and send-ups to achieve new levels of bathtime fun for kids.

Working with the unintelligible language and humorous antics of Taz, Maddocks & Company also devised a graphic solution to appeal to the adult male segment of the Warner Brothers consumer base.

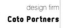

T'Gallant Wines

This demi-vache wine was produced in very small quantities and only sold in half bottles. The graphics are as voluptuous as the wine.

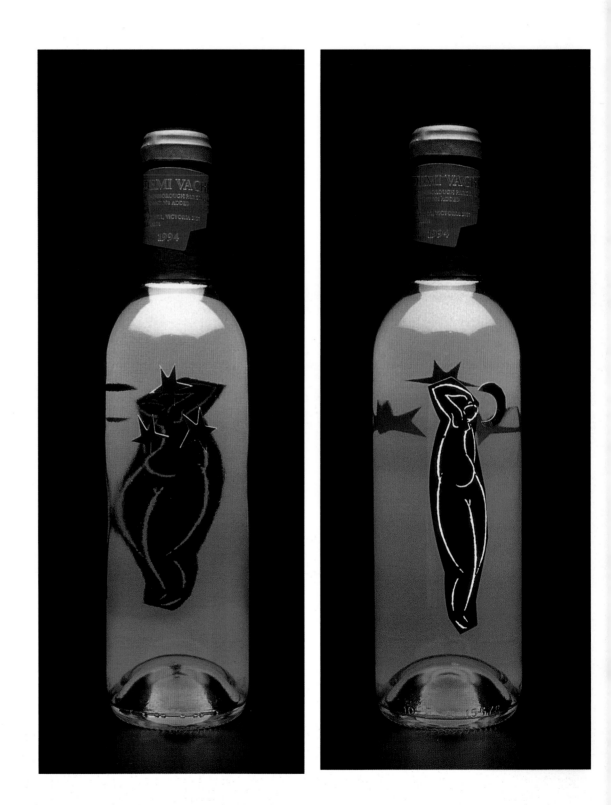

This particular wine was named after the wine maker's daughter. The labeling and the style of wine was meant to appeal to female consumers.

T'Gallant is a small boutique winery in Victoria, Australia. One of its most distinctive wines is the Holystone, a blend of pinot noir and Chardonnay. The main label design, which has particular appeal for women, consists of a decoupage of old fashioned roses, and is actually a double-sided label on the back of the bottle.

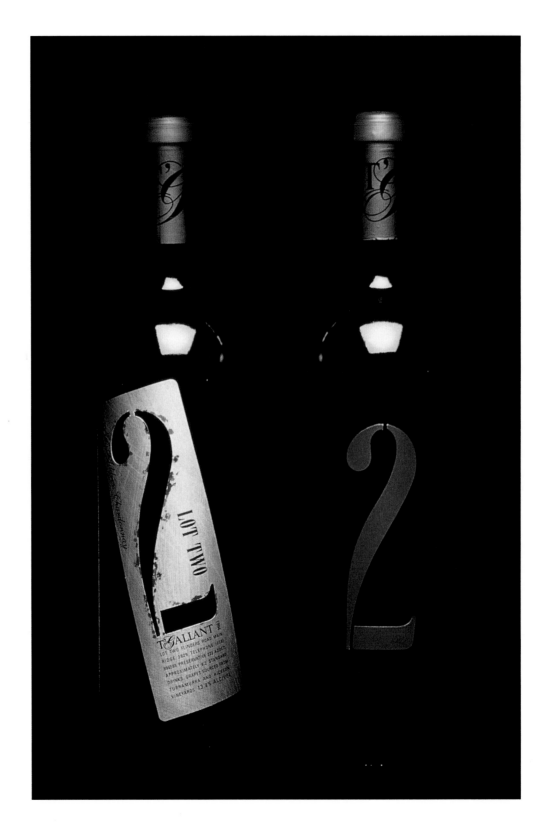

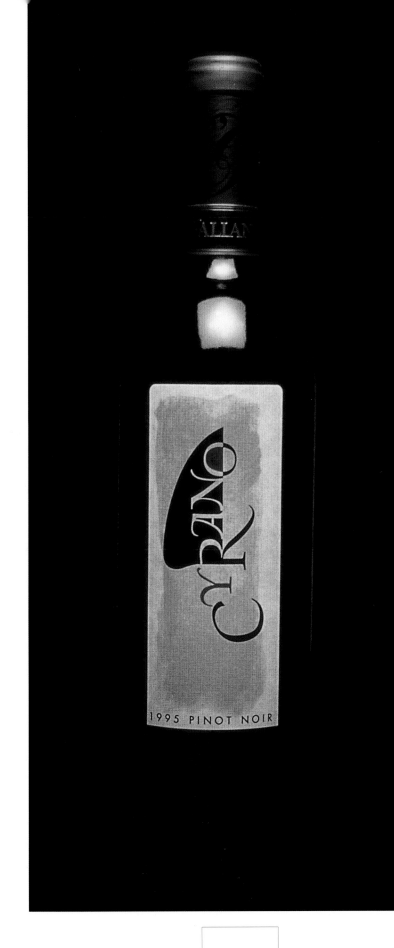

This red wine was named Cyrano because in wine terminology it has a great nose. The name was used to form a face typographically.

design firm
Cornerstone
creative director
Keith A. Steimel

Kellogg's Breakfast Mates

Designed to help young children prepare their own breakfasts, Kellogg's Breakfast Mates package cereal, milk, and a spoon all in one container. Animated arms reaching out from the type illustrate how the product works while leading the eye to the familiar Kellogg's cereal type contained in the package.

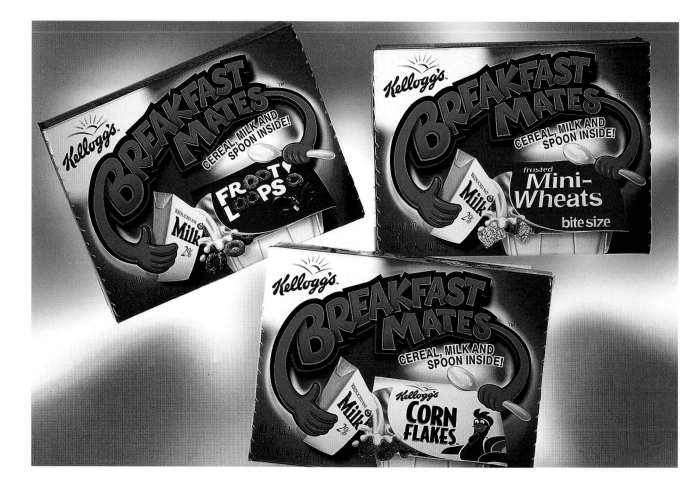

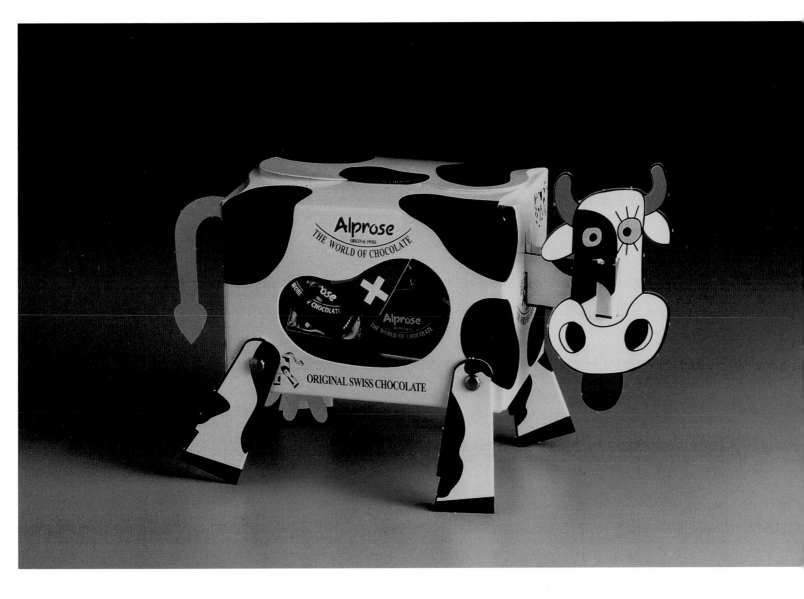

design firm
G/D/S **Alprose Napolitaine**
This cute little cow holds several different types of Alprose brand Swiss chocolates. The client requested a package that
would prompt impulse purchases at Swiss tourist sites and in airport duty-free shops.

design firm
Fitch Inc.
designer
Nick Richords

Soho Spice

Soho Spice is an Indian restaurant located in the Soho area of London. Soho Spice also markets a line of spices for sale within the restaurant. The pure, natural quality of the spices are showcased by clear glass cylindrical packages. Labels are produced in a range of warm earth tones to complement the all natural ingredients of the spices and to enhance their natural color qualities. All spices are represented on the label by text and photographs.

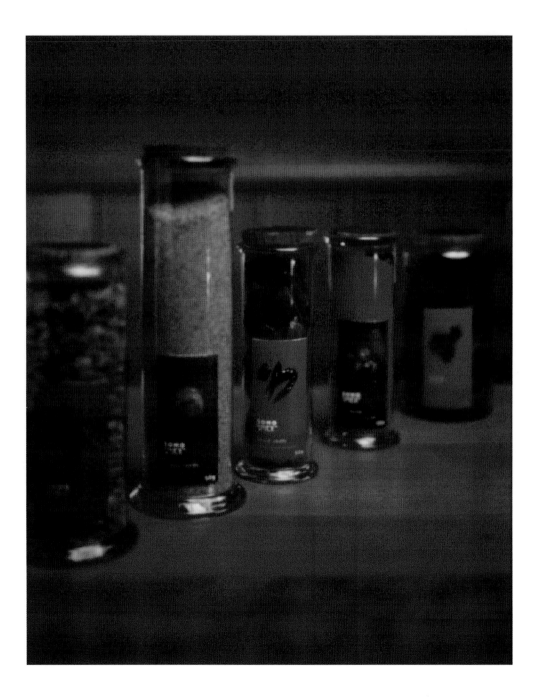

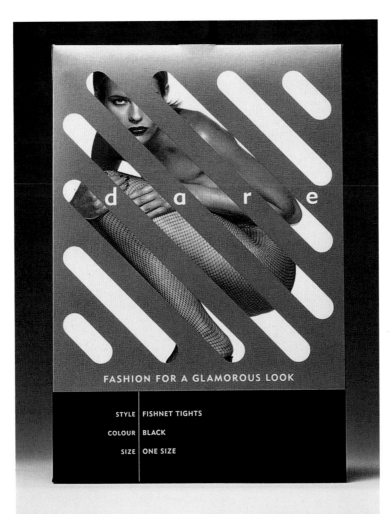

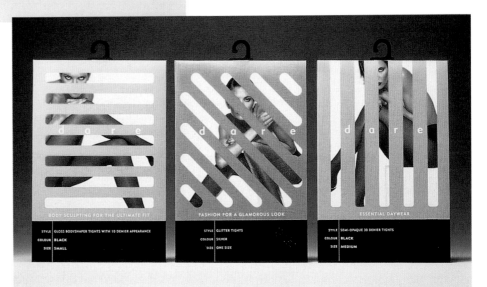

design firm

Turner Duckworth

art directors

David Turner, Bruce Duckworth

designer

Bruce Duckworth

photographer

Tim Platt

Dare Hosiery

Hosiery packaging usually uses a die-cut window to show the color and texture of the product. The packaging for Dare hosiery shows glamorous women, wearing only the product. The design treatment makes it seem as though the women are looking at they viewer from behind bars, or that the viewer is looking at the women through blinds or a screen.

design firm
Pearlfisher

Absolut Mandrin

The bottle for this new orange-flavored vodka was designed to communicate the essence of orange in a way that gives the Absolut brand new energy and strengthens its upscale image. This new bottle sits firmly within the Absolut family, yet the unexpected illusion of an orange in the base of the bottle captures the natural taste sensation and exotic appeal of the liquor.

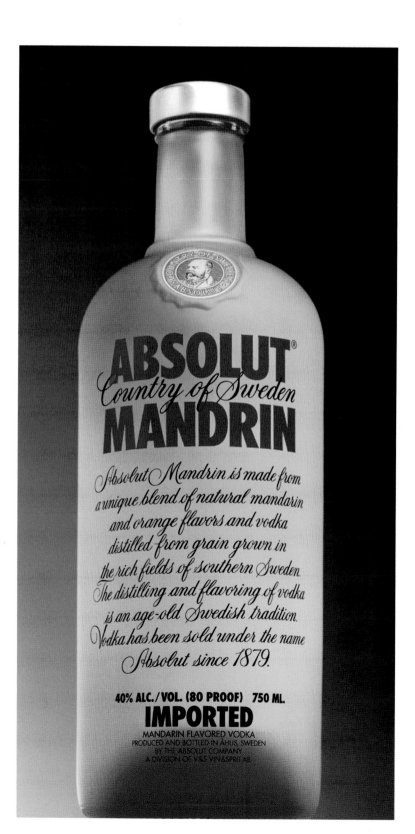

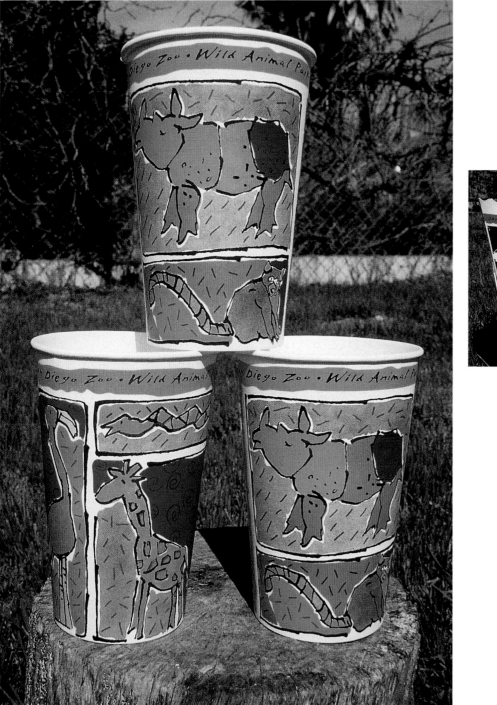

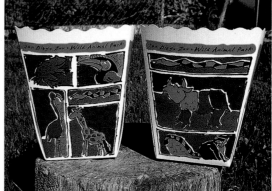

design firm
Barbara Ferguson Designs
creative director
Barbara Ferguson

San Diego Zoo

The San Diego Zoo wanted playful, colorful popcorn containers for use at their wild animal park. This approach is not only appealing to both children and adults, it also shows some of the exotic animals on exhibit at the zoo.

design firm
Hand Made s.r.l.

Stimet Prefabricati

This D-ring binder houses several booklets promoting the client's philosophy, work, and services. The booklets can easily be removed, replaced, or repositioned for each prospective client. The binder is packaged in a sturdy cardboard slipcase, covered in a glossy silver paper, which bears the company's logo.

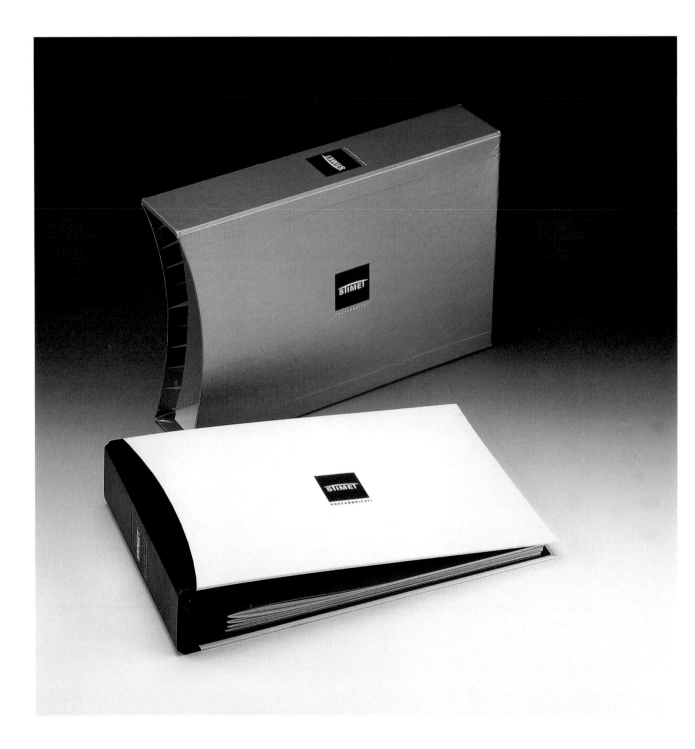

Interactive is a big buzzword. A direct mailer is said to be interactive if the recipient is required to place a sticker on a reply card; a multimedia presentation is said to be interactive if the viewer has to click on an icon to start it up.

Packaging is by its very nature interactive. The customer has to pick up the package and open it to get to the product inside. But truly interactive packaging goes a step further. Interactive packaging not only protects and brands the product inside, it offers something more to the consumer. An interactive package may sport handles to make the package easier to carry, it may require the buyer to move or turn part of the package to view the product, or it may provide long-term storage for the product.

Such packaging may also prove useful after the original product is consumed. Earlier in this century, many products were packaged in tins and sturdy boxes. These tins and boxes were often saved and used for storage or even decorative purposes. Not only does this type of packaging offer another benefit to the buyer, it reduces waste and the impact of packaging on the environment.

interactive packaging

design firm
Cartoon Network

art directors
Gary Albright, Todd Fedell

Cartoon Network

These teasers were created for two shows Cartoon Network launched last year—*Ed, Edd n Eddy* and *Powerpuff Girls*. The creative team chose candy as the "product" because it's inherent in the shows: The Eds are constantly eating or trying to get jawbreakers and the Powerpuff Girls were created from sugar, spice, and everything nice, plus a secret ingredient. These pieces were mailed to cable affiliates, advertisers, and media contacts.

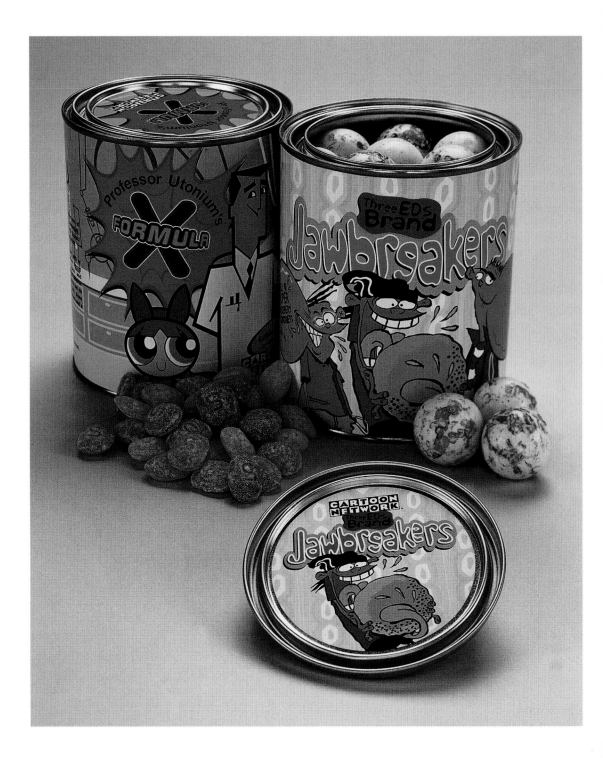

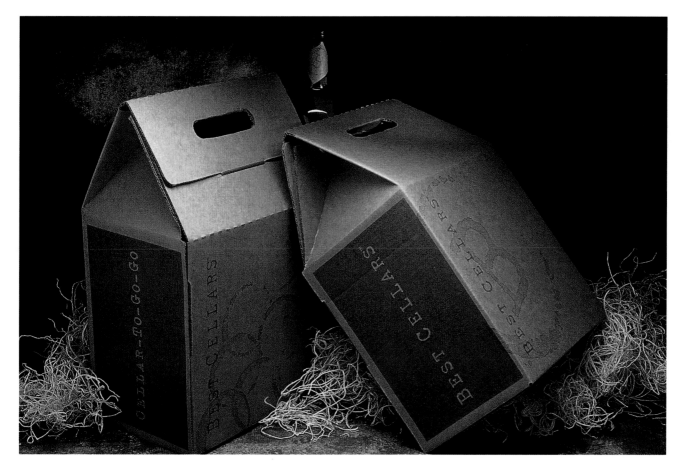

design firm
Hornall Anderson Design Works, Inc
art director
Jock Anderson
designers
Jock Anderson, Lisa Cerveny, Jana Wilson Esser

Best Cellars

For Best Cellars, a New York wine distributor and reseller, the objective was to convey affordability without compromise. As a result, an unpretentious identity was designed using the concept of a wine stain. This shape defines the C of Cellars. The typographic treatment of the B complements the roughness of the stain. The identity was applied in a one-color graphic to the Kraft box stock of the wine-bottle carrier boxes.

design firm
Tom Fowler, Inc.
art directors
Elizabeth P. Ball, Peter Bertolini
designers
Elizabeth P. Ball, Thomas G. Fowler

Pond's

Pond's Prevent and Correct packaging comprises a unique two-piece jar designed for a two-step skin care product. The top (white) half of the jar is for the daytime skin cream and the bottom (black) half of the jar is for the nighttime skin cream.

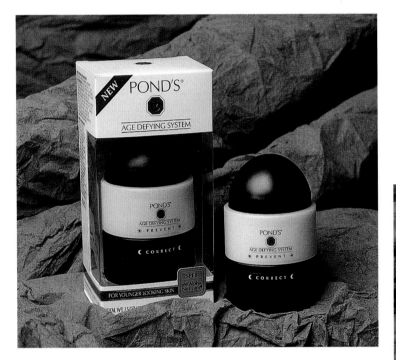

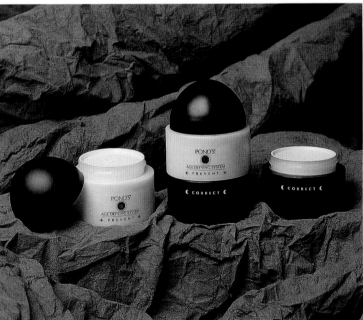

design firm
2 Graphic Design
designers
Ole Lund MDD, Jon Nielsen MDD, Tobias Rosenberg (Grey Copenhagen)
photographer
Morgan & Morrell

Danish National Radio

This book both promotes the Danish National Radio satire sketch program, *Selvsving*, and serves as a package for two CDs. The heavy board book looks like a radio, and the CDs are printed with radio-dial style numbers, so that when they are turned, it appears that the viewer is tuning a radio dial.

design firm
Goodhue & Associés
project director
Luc Goodhue
creative director
Lise Charbonneau
art directors
Nicolas Jouhannaud, Sylvain Souvé
designers
Aube Savard, Claude Rivard
photographers
François Brunnelle, Jean Vachon
illustrators
Florent Dufort, Jacques Perreault

Microcell Solutions/Fido Service

The runaway success of its Fido PCS offering led Microcell Solutions to revamp its packaging: a unified, user-and employee-friendly design was necessary. One box now fits all: a single package accommodates handsets, smart cards, batteries, chargers, and user documentation in varying configurations. The puppy is a recurring motif and creates synergy with Microcell's TV and print ads.

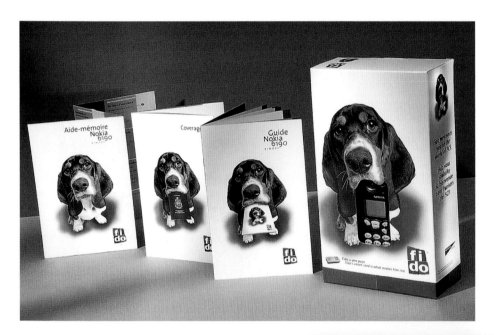

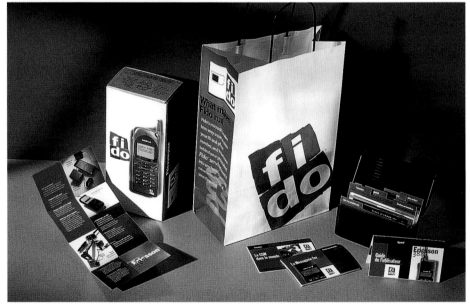

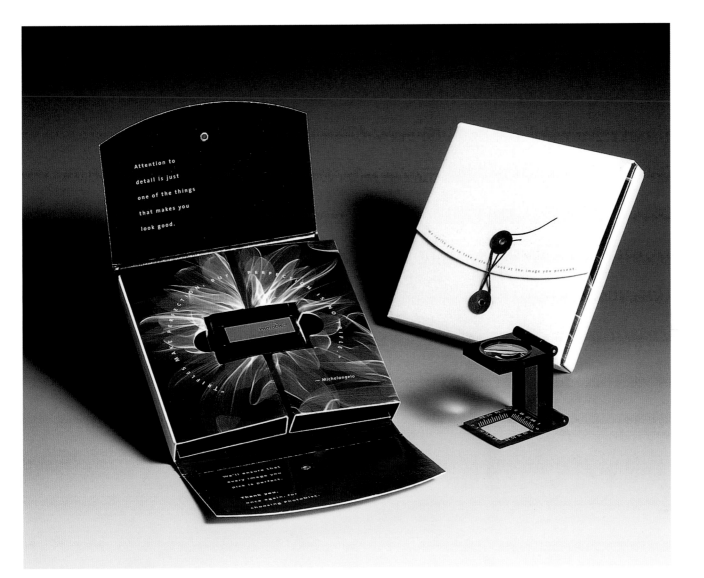

design firm
PhotoDisc In-house Creative
art director
Kelly Kyer

PhotoDisc

This piece serves several purposes. It's a self-mailer with promotional copy printed on the inside flaps, the packaging protects and encloses a loupe that recipients can use to view images offered in the company's stock photography catalog, and the package serves as a place to store the loupe.

design firm
PhotoDisc In-house Creative
art director
Kelly Kyer

PhotoDisc

This promotional millennium calendar is actually a two-year calendar—when 1999 is over, the piece flips over for the year 2000. The attractive metal case containing the calendar can later be used to hold small office supplies, photos, and so on.

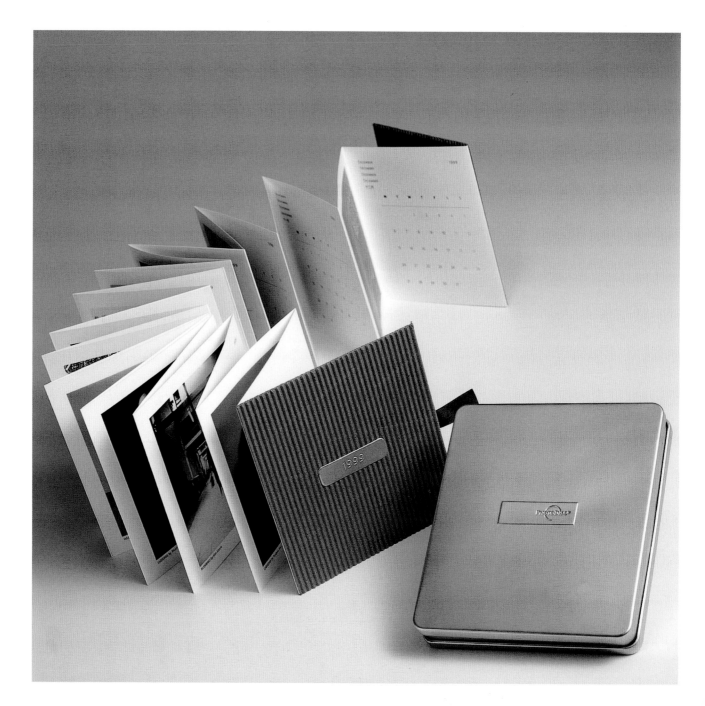

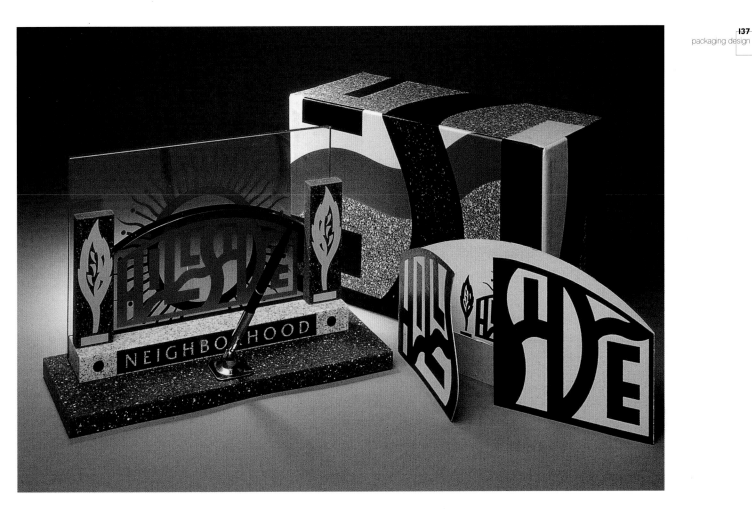

design firm
Soyles Graphic Design
art director
John Soyles
designer
John Soyles
illustrator
John Soyles

Hillside Neighborhood
This custom-packaged pen set, made from Plexiglas and the building material Avonite, was sent to developers in a sturdy box, along with an invitation to participate in the development of a new neighborhood.

design firm
Sayles Graphic Design
art director
John Sayles
designer
John Sayles
photographer
John Clark

Hotel Pattee

This gift box was designed for guests of the recently renovated Hotel Pattee. It is meant to remind guests of the hotel's 1913 origins, as well as the railroad industry, which was prominent in the area at the time.

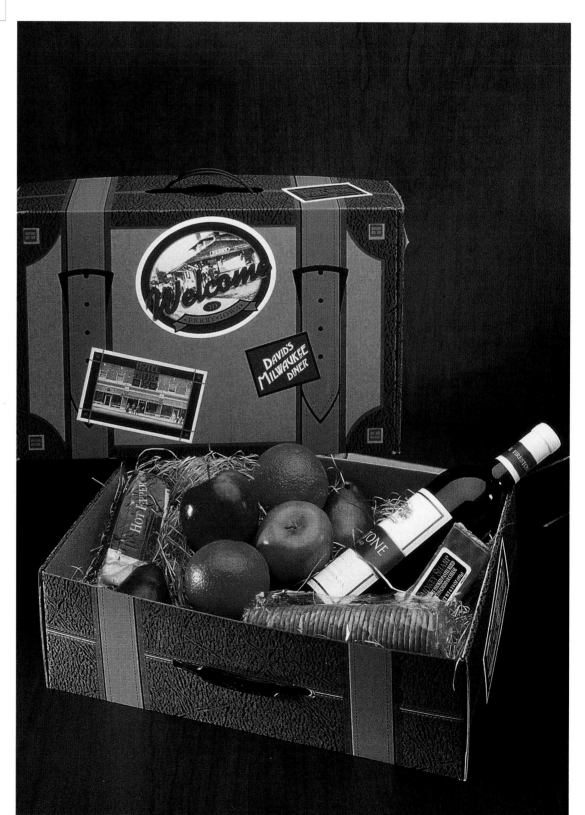

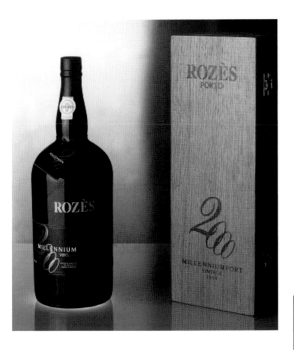

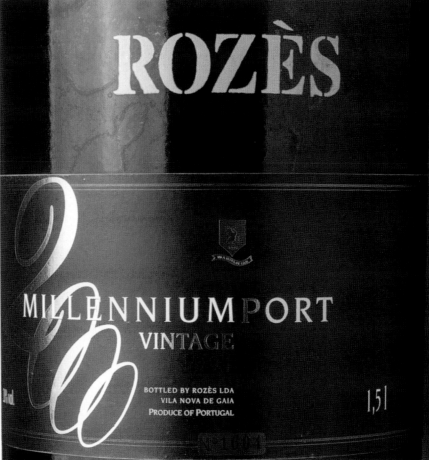

design firm
R2 Design
designers
Lizá Defossez Ramalho, Artur Rebelo

Rozès Porto

The case protecting this special port wine designed to celebrate the millennium is made of wood because the material is connected with the process of making wine, and it implies value and quality. The firm designed the millennial 2000 type to subtly remind the viewer of a bunch of grapes.

Exedo

Exedo is a new leisurewear brand from Bally of Switzerland. The footwear is packaged in a unique, clear, reusable box that not only enables the customer to see the product, but also gives him or her an added bonus—a free storage box. The box lids are embossed with the Exedo logo and it appears again on a red label on the side of the box.

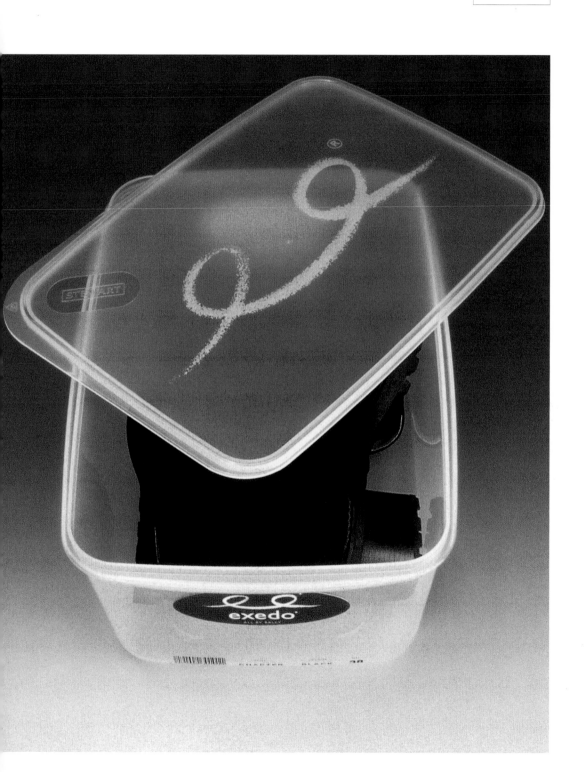

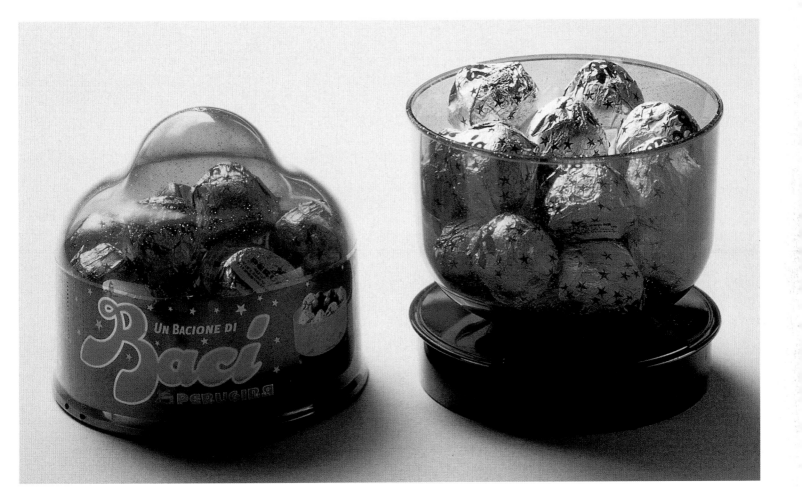

design firm
Minale Tattersfield & Partners

Baci Perugina

This new packaging format is designed in the shape of a large Baci chocolate. Inside, one can see the silver-wrapped chocolates. Once opened, this innovative package doubles as a presentation bowl elegant enough to be used for any occasion.

design firm
Free-Range Chicken Ranch
art director
Kelli Christmon
designer
Kelli Christmon

Netcom/NetCruiser

This package offers customers everything they need to get on the Internet, all in one box. The firm designed a retail software box, the disk jacket, the instructional brochure, and the point-of-purchase (POP) displays that hold several disks. These POPs were displayed on the checkout counters of computer stores and they hold several demonstration disks that sold at about $5 each. The POPs were also displayed on the software shelves and at trade shows as giveaways.

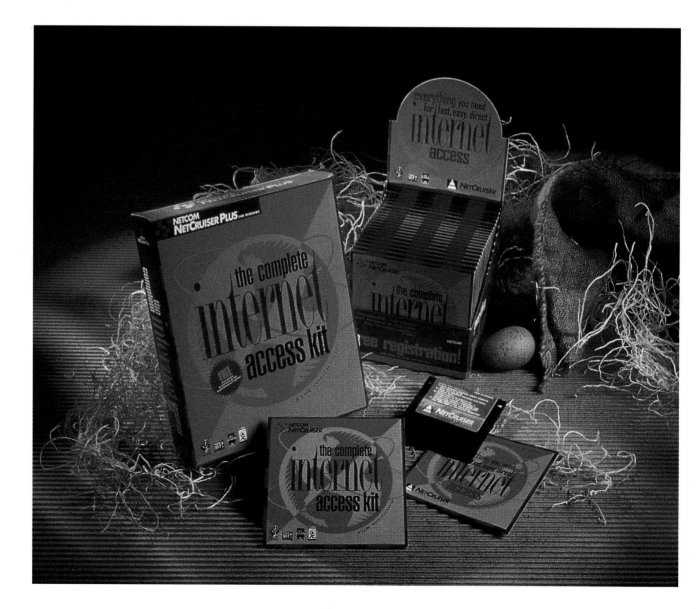

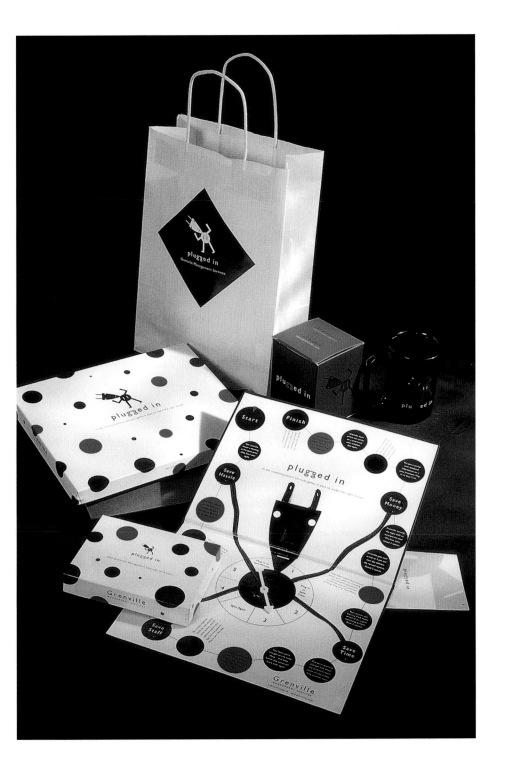

design firm

Vivo Dolan

art director

Frank Vivo

designer

Frank Vivo

Grenville Management Services

The purpose of this piece was to explain what the client does—printing on demand and other communications management services—while creating a door-opener for salespeople. The board game incorporates traditional sales messages into an unusual, three-dimensional, interactive keeper that also demonstrates the quality of digital printing.

design firm
Viva Dolan
art director
Frank Viva
designer
Frank Viva
illustrator
Frank Viva

Conquerer Papers

This point-of-purchase display for Conquerer Papers is an effective way to present free samples to prospective buyers. The old-fashioned typewriter containing the samples, and the supporting graphics and typography help to convey the idea of quality stationery.

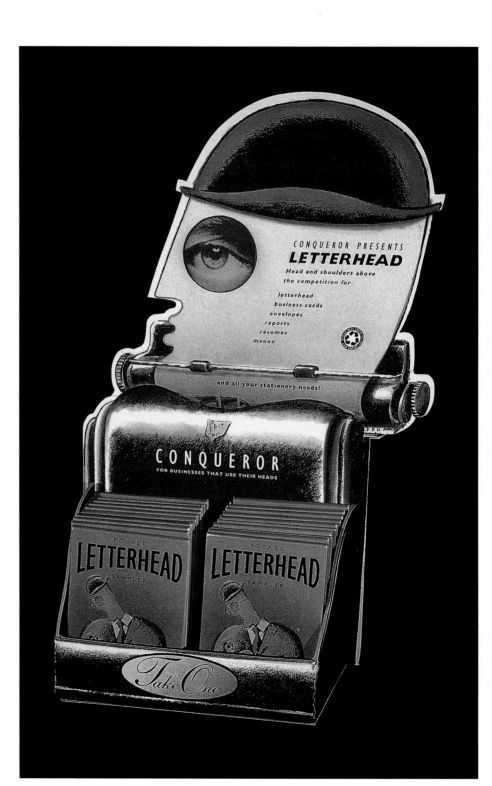

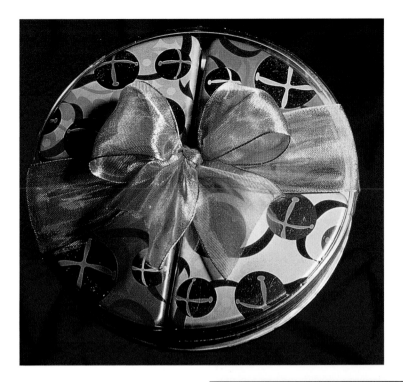

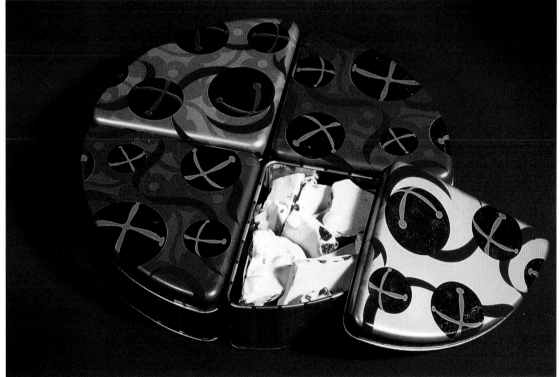

design firm
Lombert Design
art director
Christine Lombert Rasmussen

Duo Delights

The pie-shaped wedges of the Duo Delights holiday tins are made to work together or to function separately. The tins are packaged in round acrylic containers and topped with gold bows for holiday gift giving.

design firm
Fossil Portners, Ltd.
art director
Tim Hole
designer
John Dorcas
photographer
Dove McCormick

Fossil

Fossil produces an annual kit to entice collectors to join the Fossil Collectors Club. The theme for the 1998 kit evokes a nostalgic train theme.

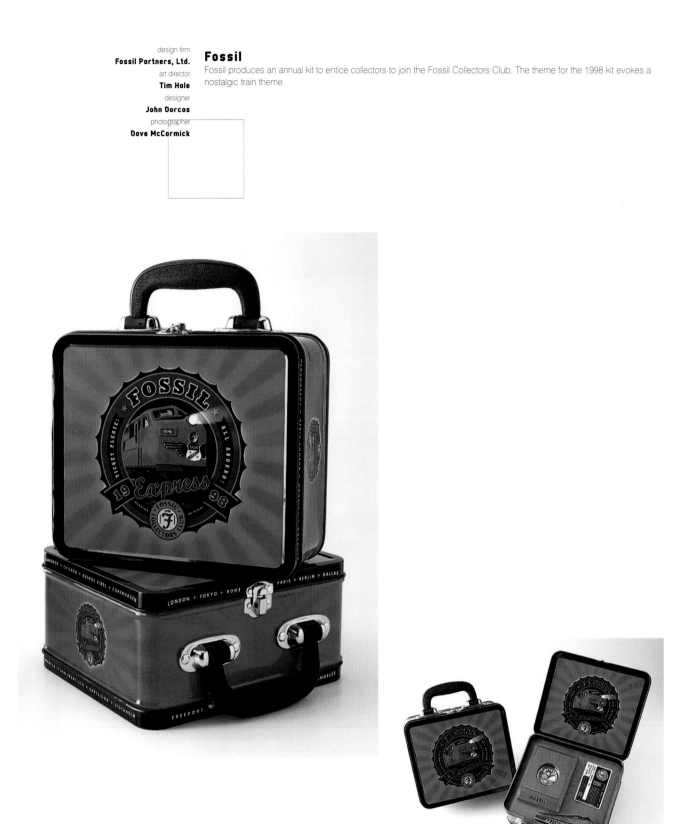

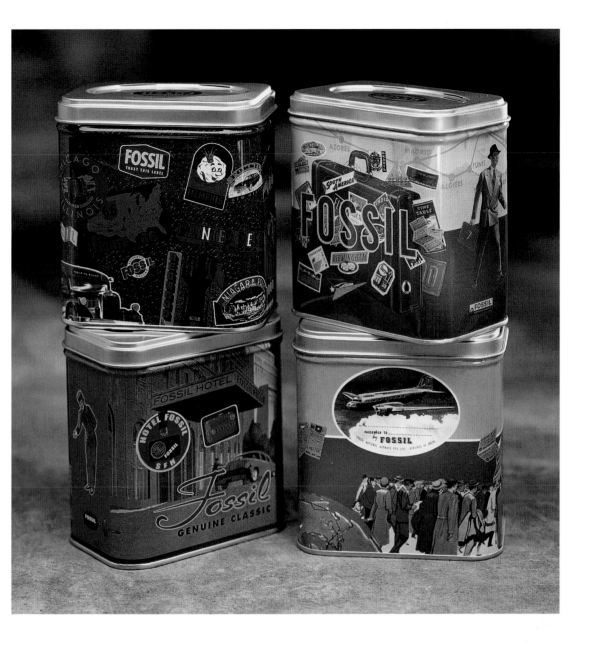

design firm

Fossil Partners, Ltd.

art directors

Clay Reed, Steven Zhang, Casey McGarr

designer

David Eden

photographer

Dave McCormick

Fossil

These assorted watch tins employ a fun, retro travel theme. The tins are quite collectible, so the designers create several different looks for them each year.

design firm
Fossil Partners, Ltd.
art director
Tim Hale
designers
John Dorcas, Casey McGarr
designers
Dave McCormick

Fossil

Fossil produces over seventy-five novelty tin designs each year. These tins were designed from letterpress posters printed by Hatch Show Print in Nashville, Tennessee.

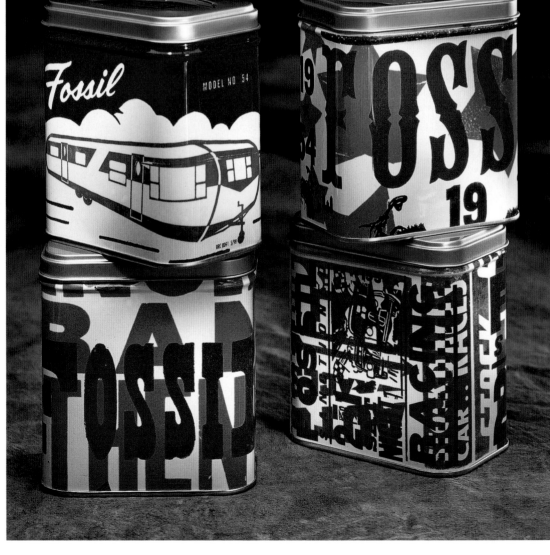

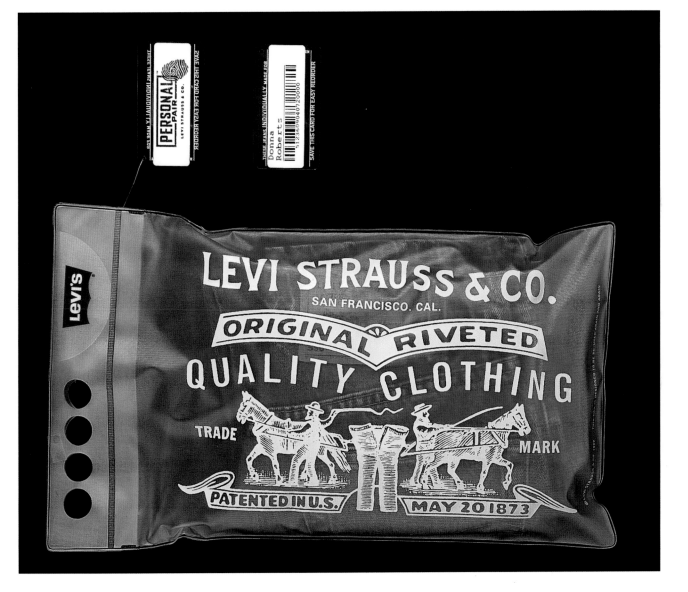

design firm
Turner Duckworth

art directors
David Turner, Bruce Duckworth

designers
Jeff Fassnacht, David Turner

Levi Strauss/Original Spin

Developed to house custom jeans from Levi Strauss & Co., this reusable frosted vinyl bag gives the traditional Levi's graphics a contemporary edge and was designed to be mailed to the customer or collected from a store. Each bag has a personal ID tag attached with the customer's name and code number.

design firm
Fitch
designers
Fitch:
Don Stoufenberg, David Gresham, John Davison;
Morningstar:
Robert Soto, David Williams, Phillip Burton

Morningstar Mutual Funds

Morningstar Mutual Funds is a privately held company that analyzes mutual-fund performance and reports this information through a subscription service to investment analysts and advisors, business publications and individual investors. Originally, the regular series of printed subscription reports were stored and accessed in a large three-ring binder. While subscribers reported overall satisfaction with the service, users complained that the original binders were difficult and cumbersome to use. Fitch's solution involved eliminating the traditional three-ring binder to allow each booklet to be easily removed, pages more easily flipped through, laid flat for copying, and easily replaced. The insertion and removal of the booklets now takes less time and only one hand.

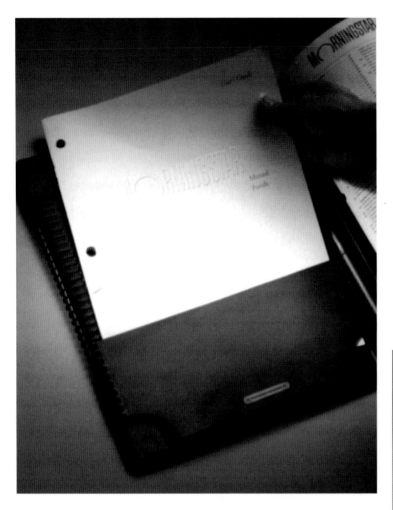

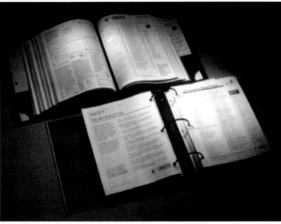

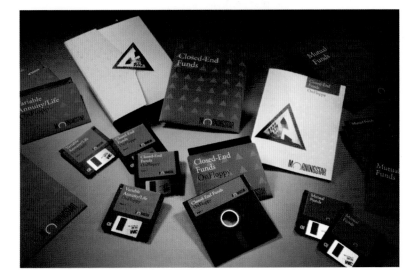

design firm
Novodesign

ViniPortugal/Alma Latina

Promoting the Portuguese wine sector, "Alma Latina" (Latin Soul) is the concept of the identity campaign, which was extended to a promotional gift pack. The pack is composed of a basket containing a specially designed wine bottle, corkscrew, and a booklet describing the eight main aromatic definitions, which make up the specific types of Portuguese wines.

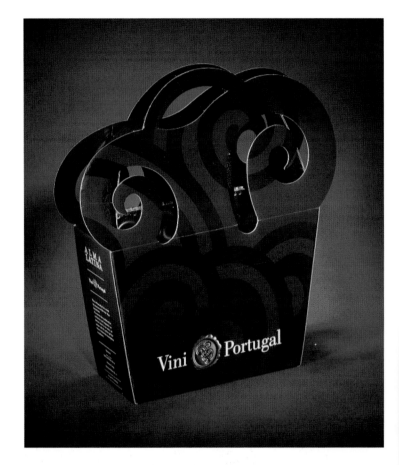

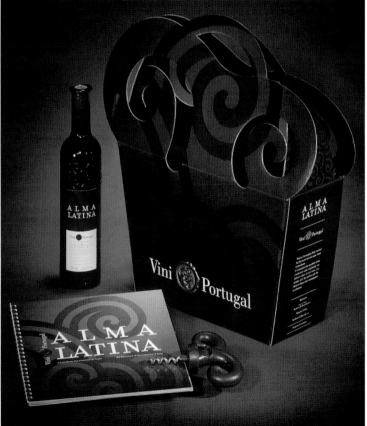

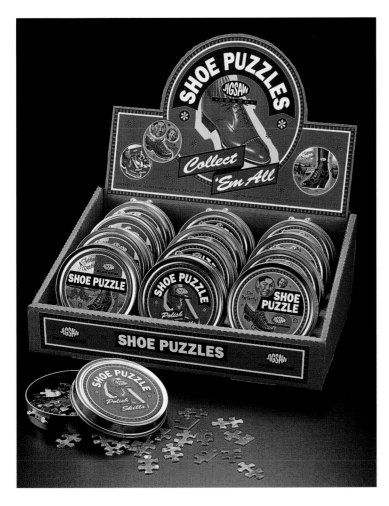

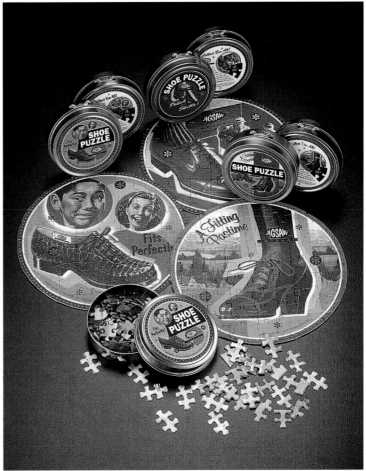

design firm
Michael Stanard, Inc.

art director
Michael Stanard

designer
Kristy VandeKerckhove

Jigsaw Brand shoe puzzles

These fun, retro shoe puzzles celebrate the great shoe advertising graphics of the 1920s, 1930s, and 1940s. The puzzles come in concept-appropriate shoe polish tins, and are sold in a point of purchase display that mimics those used to sell shoe polish.

design firm
Michael Stanard, Inc.
art directors
Michael Stanard, Marc C. Fuhrman
designers
Marc C. Fuhrman, Michael Chang

Lionel Trains

These packages for Lionel Trains were developed for a variety of products. The Lionel Trains Starter Set is a consumer-friendly package with an easy-to-carry feature for the oversized packages. The slip-case style boxes open in front and reseal with a Velcro tab for years of safe storage. The Postwar Celebration Series packaging holds reissues of iconic products from the postwar era; both the trains and the packages are collectible. The Track Pack boxes contain add-on sets of Lionel track; the client wanted a "factory parts" look and feel to the design. The bold orange and blue Large Scale boxes were designed to help Lionel re-launch their line of G-scale model trains.

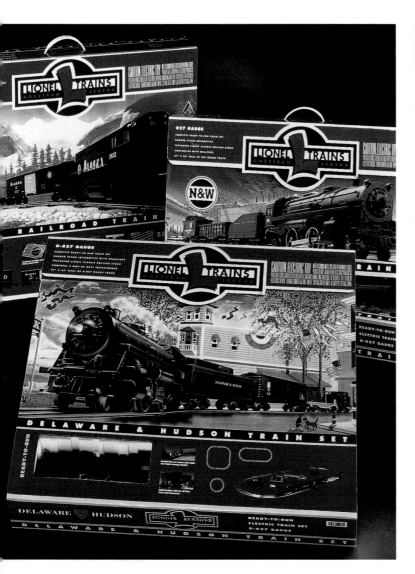

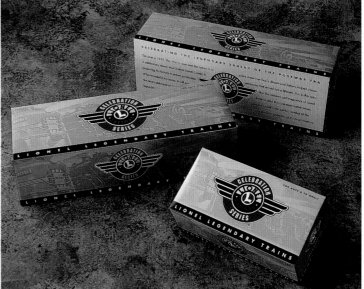

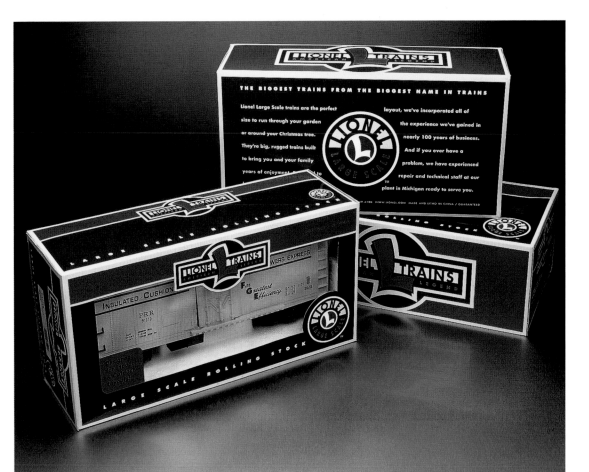

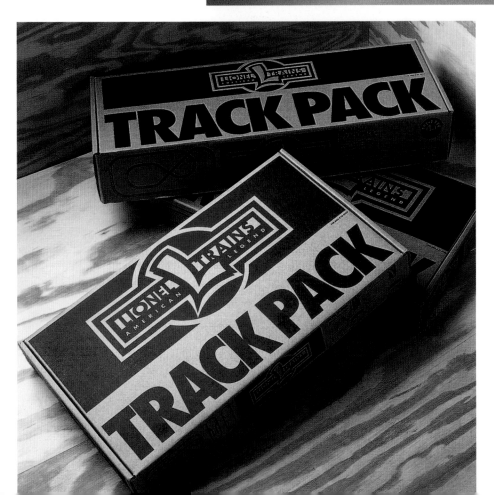

design firm
Maddocks & Company
creative directors
**Mary Scott, Clare Sebenius, Ann Utley Moores,
Jane VandeVoorde**

MGM/Color Studio and Flick

Maddocks & Company worked with MGM Consumer Products to create an imaginative line of cosmetics that leveraged the quality and prestige associated with the MGM Studios brand. Celebrating the romance and glamour of Hollywood, and MGM's legacy of over seventy-five years of moviemaking, these products blended the behind-the-scenes magic with the sophistication of the golden era of Hollywood. The result: a line of cosmetics that promises Hollywood style in a fresh yet classic way.

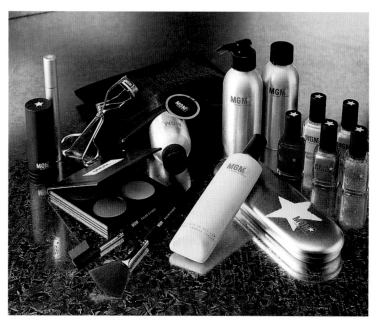

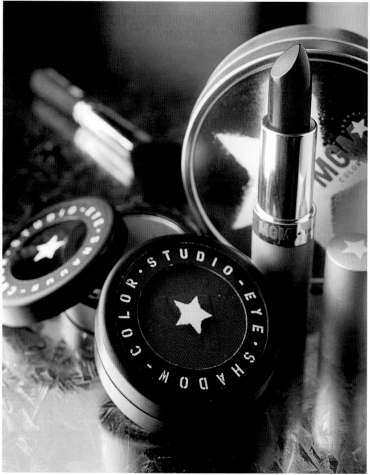

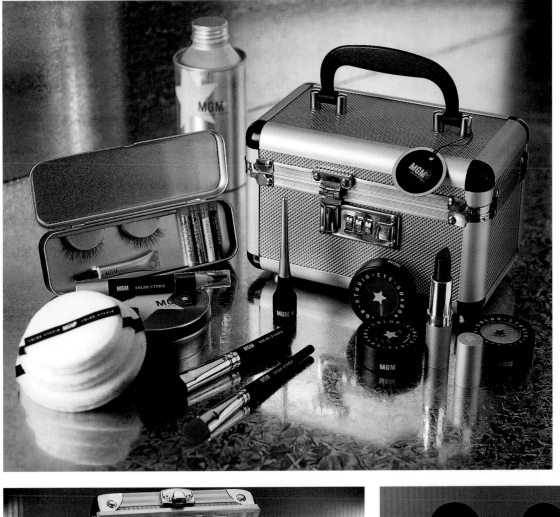

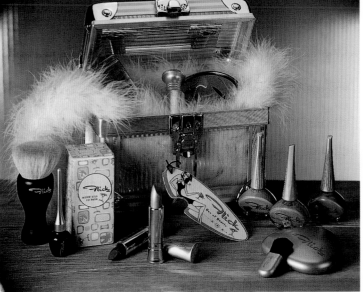

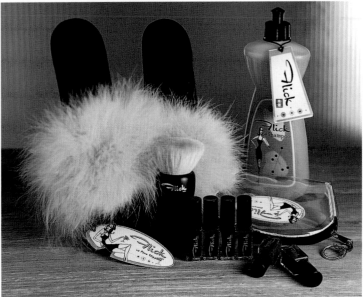

design firm
RTR Packaging & Design
art director
Ron Roznick
designer
Ron Roznick

RTR Packaging Stock Item

This translucent lunch box was designed to hold anything from a rolled-up T-shirt, to cosmetics, to gourmet sauces. The sturdy handle and clasp make the box useful to consumers long after its initial use.

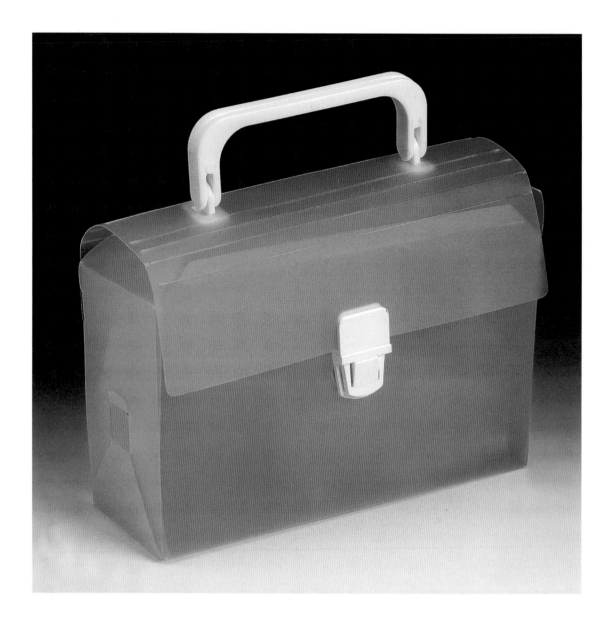

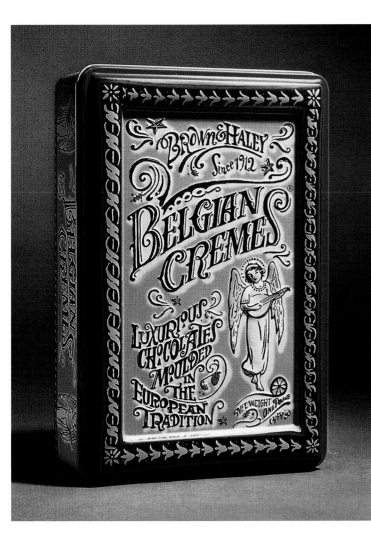

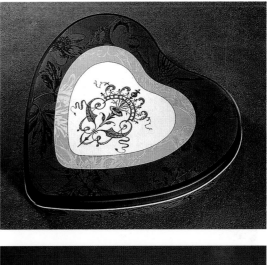

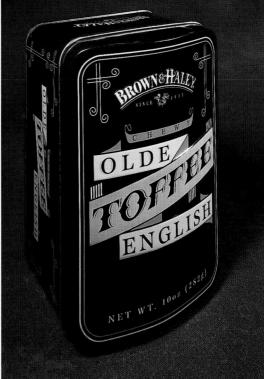

design firm
David Lemley Design
art director
David Lemley
designer
David Lemley

Brown & Haley

The Belgian cremes tin, the Valentine tin, and the English toffee tin were all designed to be kept by consumers and reused. The Belgian cremes tin uses a multilevel sculptured emboss with matte match colors and dulling agents applied to the tin to give it an antiqued look. The heart-shaped Valentine tin has all of the product branding on the back of the package—this way, when a consumer sees it on a shelf with other heart-shaped candy boxes, it stands out. The English toffee package is a redesign of a specialty product that the company originally produced in the mid-1960s. It was intended as a seasonal item, but the new package has made the candy so popular that it is produced year-round as a staple in the product line.

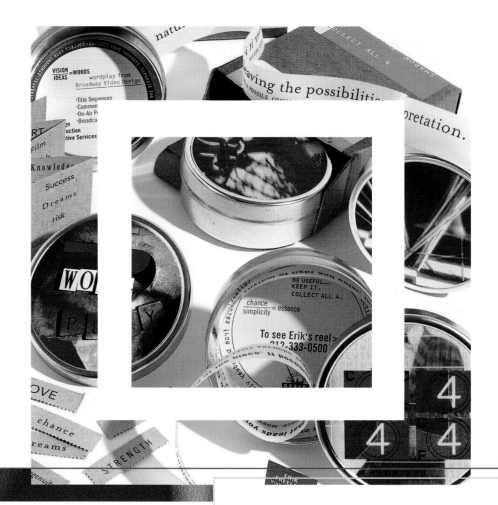

VISION
IDEAS = WORDS
wordplay from
Broadway Video Design

·Title Sequences
·Commerci
·On-Air Pr
·Broadca
·tive Services

Film

Knowledg

Success

Dreams

risk

WO
P
Y

aving the possibilities

retation.

natu

COLLECT ALL 4

BE USEFUL...
KEEP IT.
COLLECT ALL 4.

chance
simplicity = essence

To see Erik's reel >
012-333-0500

OVE

chance

reams

STRENGTH

4

4 4

ERIK
VE

A designer I once worked with suggested the following title for an article on CD and floppy disk labels and packaging: "CDs and disk labels—another damn thing to design." However, most of the designers I spoke to while collecting materials for this book love to work on packaging. It gives them a chance to get away from the typical flat design fare, such as stationery, print ads, billboards, and so on. Packaging design gives the designer a chance to think, work, and play in three dimensions.

promotional packaging

Packaging design is so much fun that many designers don't want to go back to their two-dimensional work, although such work is usually what pays the bills. The chance to work on a promotional campaign often gives designers a chance to play with packaging again. Self-promotions or promotional pushes for new products have to be noticed, so packaging is essential.

If the main piece of the promotion is flat, such as a booklet, brochure, or CD, an unusual package gains attention and draws the recipient in to the piece. Beautifully packaged promotions appeal to a wide audience—moviemakers send elaborate promotions to Hollywood movers and shakers in an attempt to influence votes for the Academy Awards; public-relations firms send packaged promotions to magazine editors to get them to cover their clients' products; graphic designers package their portfolios in an effort to attract new clients.

design firm
Tou Diseño
art directors
Jorge Garcia
designer
Jorge Garcia

Osborne

This packaged invitation announces the opening of an exhibition on Spain's famous Osborne billboard bull. The text is printed on a paper tissue, similar to the ones commonly used in Spanish bars.

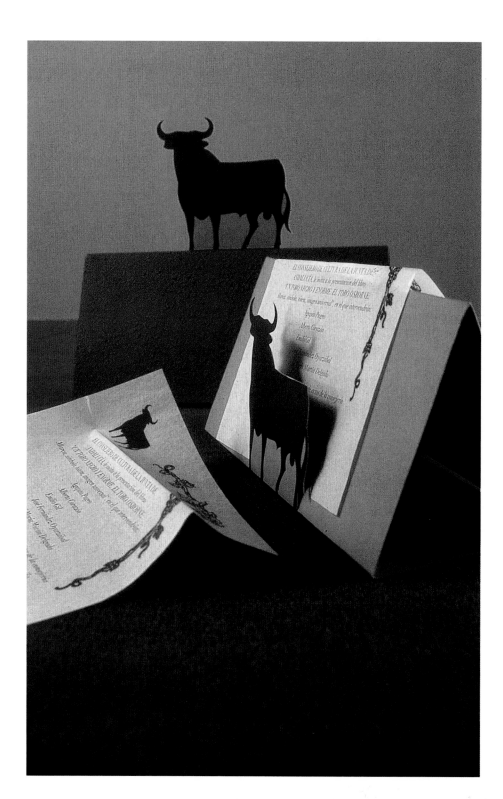

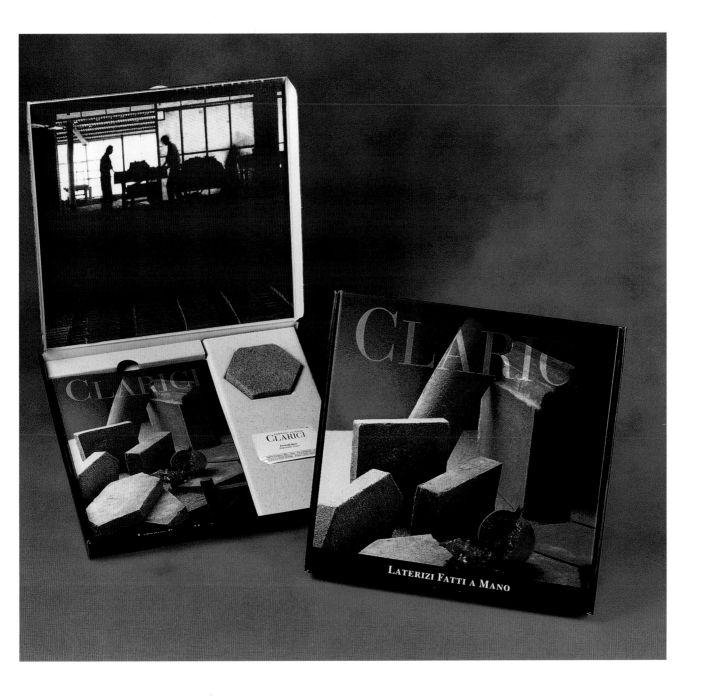

design firm
Studio GT&P di Gionluigi Tobonelli
art director
Gionluigi Tobonelli
photograher
V. Copocci

Fornaci Loterizi Clorici
This package was designed to hold brochures and a handmade brick sample to mail to architects to give them information on the product and its characteristics.

Factor Self-Promotion

This cardboard box contains a number of cards with examples of the design firm's work, a philosophical introduction, case studies, and contact information. The piece serves as a sort of permanent portfolio for clients' reference.

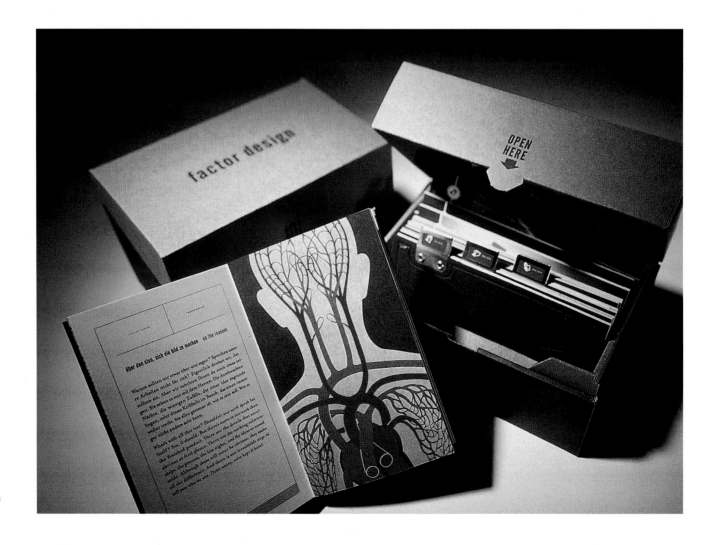

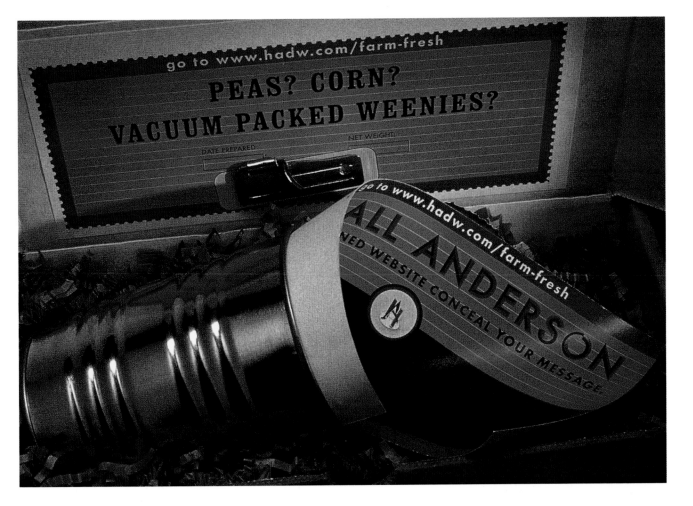

Hornall Anderson Design Works, Inc. Self-Promotion

This clever direct-mail promotion uses two packages to promote the design firm's message. The label on the inside top of the plain Kraft box entices recipients to check inside the tin can to see what it contains. Inside, a printed slip advises, "Don't let a canned Web site conceal your message." The slip directs recipients to the design firm's Web site in order to explore the custom Web-site design options offered by the firm.

design firm
Vaughn Wedeen Creative
art director
Rick Vaughn
designer
Rick Vaughn
production
Kristine Dusing

Vaughn Wedeen Self-Promotion

Vaughn Wedeen Creative had just launched a new identity, and with that in mind, they decided to send a promotion that was uniquely individual and hard to forget (or throw away). The four crate promotions were sent to individuals at four different companies. The theme word on the crate wrap and 3-D graphic with hang tag and copy was customized for the individual and his or her company. Each crate promotion was hand assembled from existing wooden crates that were painted with theme words on the outside. The crates were wrapped with striped silver cover stock, and placed in a white corrugated box filled with yellow confetti.

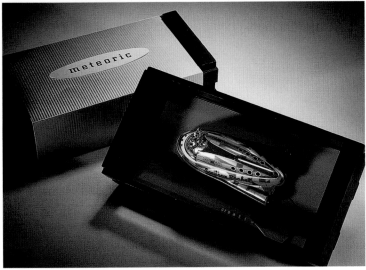

design firm
Free Range Chicken Ranch
art directors
Kelli Christman, Toni Parmley
designer
Kelli Christman

Genentech, Inc./Access

Access Excellence is an educational program that provides high school biology teachers access to their colleagues, scientists, and critical sources of new scientific information via the World Wide Web. The Access Excellence disks and promotional pamphlets were given away at teacher seminars and trade shows to promote networking among biology teachers; they were also mailed to teachers who requested the software.

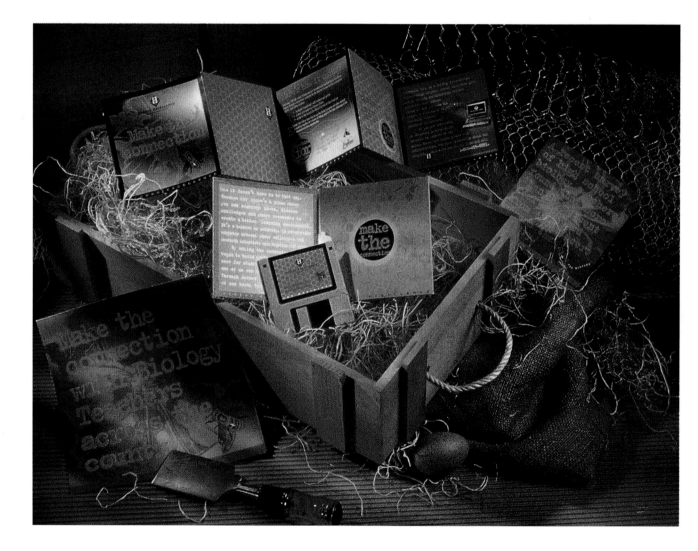

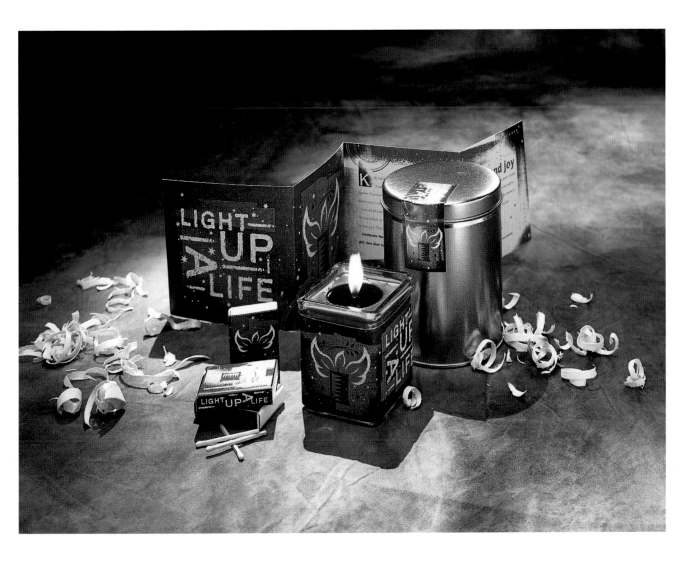

design firm
The Greteman Group
art director
Sonia Greteman, James Strange
designers
James Strange, Craig Tomson
illustrator
Deanna Harms

Candlewood Suites/Light Up a Life 1998 Holiday Promotion

The theme Light Up a Life builds on the symbology of the Candlewood name and the logo's imagery. In addition to their symbolism, the gift items—a candle and customized matchbook within a graphic tin—are appreciated by the recipients for their usefulness. The greater gift was a contribution to Big Brothers & Sisters of America on the recipient's behalf. Big Brothers & Sisters enjoys high credibility and has a proven track record of making a difference. It offered the perfect means for Candlewood Suites to "Light Up a Life." The gift was given to the recipient in person by a Candlewood Suites team member, further communicating the spirit of the campaign.

TP Design Self-Promotion

This package was sent to a variety of clients and potential clients; it showcases a variety of the firm's work in an enclosed booklet. The special carved box tucks the miniportfolio away and doubles as an attractive storage container.

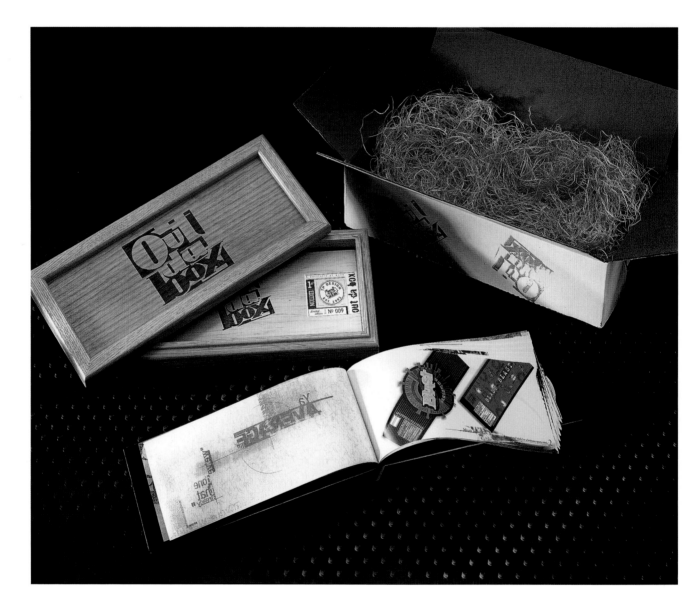

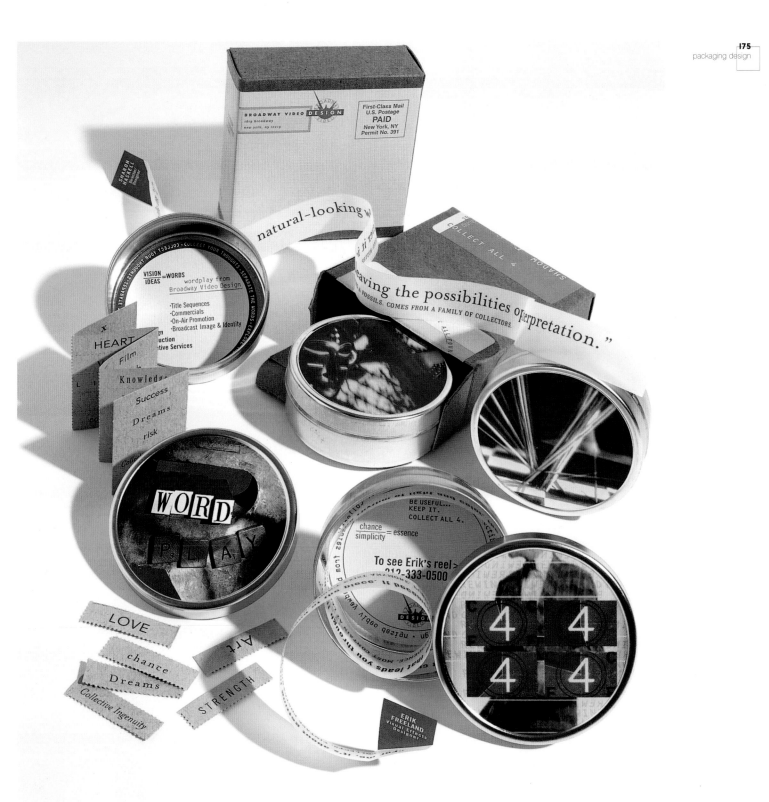

design firm
Clore Ultimo, Inc.
art director
Clore Ultimo
designers
Clore Ultimo, Cynthia Spence
photographer
Christopher Weil Photography

Broadway Video Direct-Mail Promotion

To promote the various creatives in this firm of video designers, Ultimo developed a series of collectable tins. A separate tin was created for each designer, containing a quote and other information, with a final tin sent to summarize the group's capabilities.

design firm
Gregory Thomas & Associates
art director
Gregory Thomas
designer
Pam Kato

Government of Queensland, Australia

A simple tag promoting Queensland, Australia is attached to the cover of this corrugated pouch containing an invitation to visit the country. Each invitation is accented with a painted wooden boomerang as a gift for recipients.

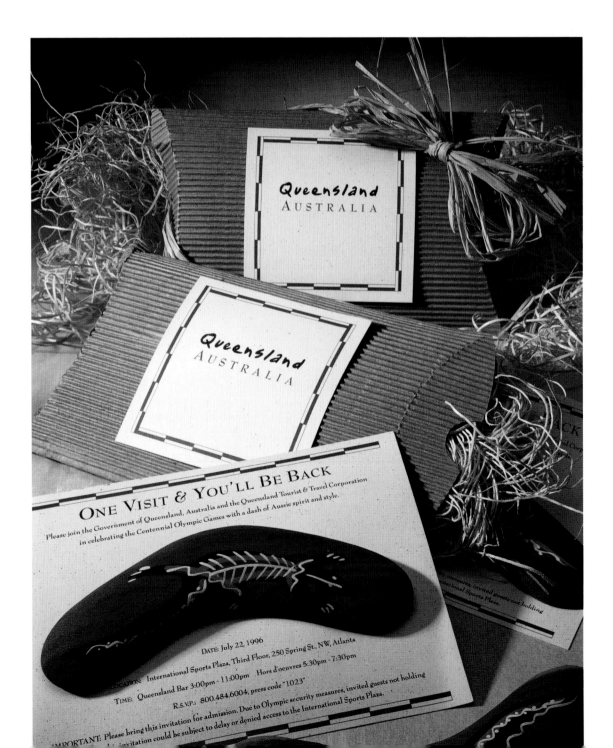

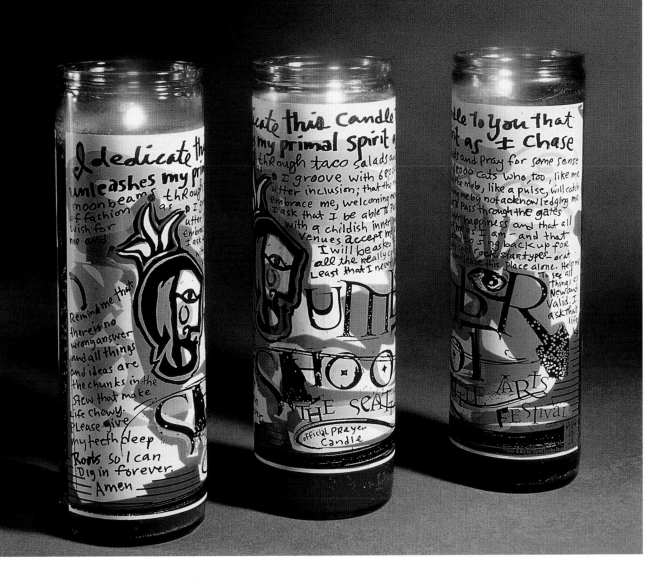

design firm
David Lemley Design
art director
David Lemley
designers
David Lemley, Matt Peloza

Bumbershoot Prayer Candle

This is the "official" prayer candle of Bumbershoot, the Seattle Arts Festival. Meant to be a new twist on the collectible souvenir, its design is intentionally tacky, with a fun message for the recipient.

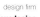

Buondi Coffee Gift Pack

Buondi is one of the leading Portuguese coffee brands, owned by the Nestlé Group. The coffees are only distributed through the café and restaurant trade, and are not available for home consumption. As a combination of a commercial opportunity and brand positioning support, the Art Collection gift pack was introduced. The pack contains an espresso set with simulations of typical art styles and a bag of Buondi coffee.

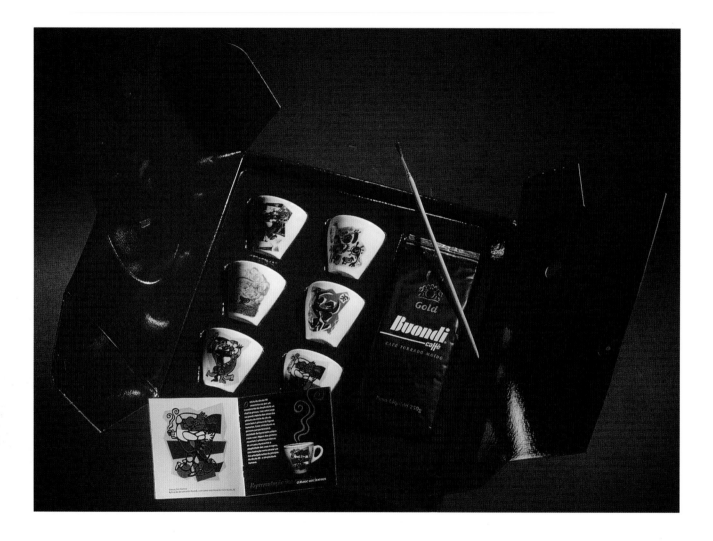

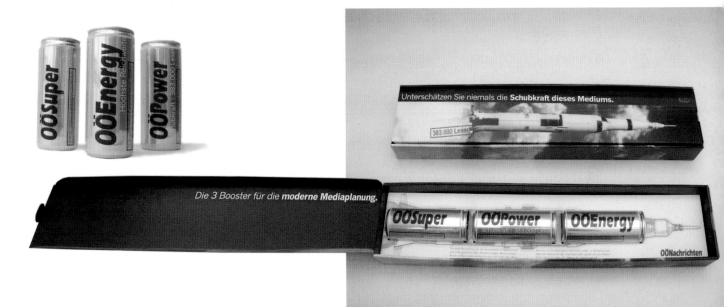

design firm
CREATEAM Werbeagentur
art director
Richard Boyer
copywriter
Norbert Tomasi

OÖNachrichten

This direct-mail piece for Austria's most-read daily newspaper included three energy drinks and was sent to media departments to encourage advertising. The box lid is emblazoned with a rocket ship, the same ship is repeated inside the box, with the silver cans making up the body of the ship.

design firm
Dynamic Grahics, Inc., In-house
creative director
Catharine Fishel
art director
Tracey Worner

Dynamic Graphics magazine

When *Dynamic Graphics* magazine wanted to tell a select group of advertisers about its readers, the staff created a package that recipients would be compelled to open. Wrapped in plain brown paper and a bow, the package gave no clue of its origin, just a tag bearing the message, "Our readers are ripe for the picking." Inside the packages are huge apples that follow through on the package's concept, plus copies of the magazine, and other promotional literature.

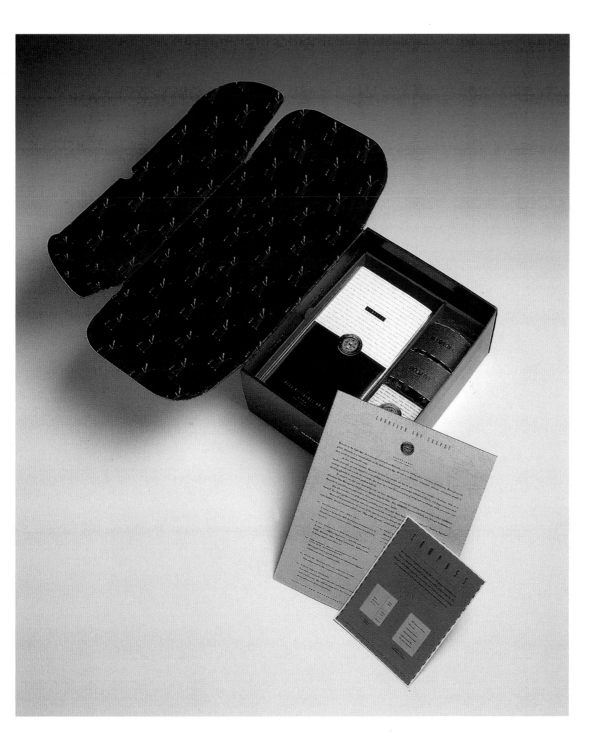

design firm
Vaughn Wedeen Creative
art director
Steve Wedeen
designers
Steve Wedeen, Don Flynn
photographer
Dave Nufer

Motorola/Compass

Motorola developed a year-long program (COMPASS) to help guide newly promoted sales managers. The program and expectations were substantial, so the packaging had to be substantial as well. Contents of the package include an introduction and overview of the program printed on a translucent cover sheet, reference guide binder, and an Accomplishment Passport with milestone stamps. Below the tray is a packet of evaluation forms as well as a course notebook, a note cube, a real compass, and a package of trail mix to kick off the process.

design firm
Hornall Anderson Design Works, Inc.
art director
John Hornall
designers
Julie Lock, Mary Chin Hutchison,
Mary Hermes, David Bates

American Biorobotics/NextRx

As a means of enticing significant VIPs to private viewings of a new pharmaceutical product, a cleverly designed invitation was created as a miniclipboard with the invitation clasped to its front. For a more personalized version of the invitation, a prescription-pad styled, glassine bag was fastened to the "clipboard" cut-out. As an additional keepsake, small packages of mints were enclosed in specially designed NextRx boxes that epitomized the client's new medication dispenser.

Design Directory

Addis Group
2515 Ninth Street
Berkeley, CA 94710

Barbara Ferguson Designs
10211 Swanton Dr.
Santee, CA 92071

Benson & Hepker
220 E. Market St.
Iowa City, IA 52245

Bessi Korovil
Corso di Porta Ticinese 50
20123 Milano
Italy

Blackburn's Design Consultants
16 Carlisle St.
London, W1V 5RE
UK

CEMK Advertising Agency Gothenburg
Sodra Gubberogata 20
S-416 63 Gothenburg
Sweden

Cartoon Network
1050 Techwood Dr.
Atlanta, GA 30318

Cato Partners
254 Swan St.
Richmond 3121
Australia

Clore Ultimo, Inc.
41 Union Square West, Ste. 209
New York, NY 10003

Cornerstone
11 East 26th St.
New York, NY 10010

CREATEAM Werbeagentur Ges.m.b.H
Spittelwiese 8
A-4020 Linz
Austria

Dagná Grafisk Design
Fiskargatan 14
116 20 Stockholm
Sweden

David Lemley Design
8 Boston St., Ste. 11
Seattle, WA 98109

Desgrippes Gobé & Associates
411 Lafayette St.
New York, NY 10003

Design Guys, Inc.
119 North Fourth St., #400
Minneapolis, MN 55401

Device
6 Salem Road
London, W2 4PU
UK

Dynamic Graphics
6000 N. Forest Park Dr.
Peoria, IL 61614

Factor Design
Schulterblatt 58
20357 Hamburg
Germany

Fitch, Inc.
10 Linday Street
Smithfield Market
London, EC1A 9ZZ
UK
and
10350 Olentangy River Rd.
Worthington, OH 43085

Fons M. Hickman
Parkstrasse 14
40477 Duesseldorf
Germany

Fossil Partners, Ltd.
2280 N. Greenville Ave.
Richardson, TX 75082

Free-Range Chicken Ranch
330A East Campbell Ave.
Campbell, CA 95008

G/D/S
Via Peri 9
CH-6900 Lugano 1
Switzerland

Goodhue & Associés
865 McGill, 8th Floor
Montreal, QC H2Y 2H1
Canada

Göthberg + Co Design ob
Skårsgatan 66
41269 Göteborg
Sweden

Graif Design
1330 W. Schatz Ln., Ste. 4
Nixa, MO 65714

Gregory Thomas & Associates
2812 Santa Monica Blvd.
Santa Monica, CA 90404

The Greteman Group
142 North Mosley
3rd Floor
Wichita, KS 67202

Hand Made s.r.l.
Via Sartori, 16
52017 Stia (AR)
Italy

Hornall Anderson Design Works, Inc.
1008 Western Ave., Ste. 600
Seattle, WA 98104

Initio, Inc.
212 3rd Ave. N., Ste. 510
Minneapolis, MN 55401

JOED Design
136 West Vallette
Elmhurst, IL 60126

Karacters Design Group
1700-777 Hornby Street
Vancouver, BC V6Z 2T3
Canada

Korn Design
22 Follen St.
Boston, MA 02116

Lambert Design
7007 Twin Hills Ave., Ste. 213
Dallas, TX 75231

Leslie Evans Design Associates
81 West Commercial St.
Portland, ME 04101

Lippa Pearce Design Limited
358a Richmond Rd.
Twickenham, TW1 2DU
UK

Louisa Sugar Design
1650 Jackson Street, Ste. 307
San Francisco, CA 94109

Maddocks & Company
2011 Pontius Ave.
Los Angeles, CA 90025

Michael Osborne Design
444 DeHaro Street, Suite 207
San Francisco, CA 94107

Michael Stanard, Inc.
1000 Main St.
Evanston, IL 60202

Minale Tatterstield & Parners
The Courtyard
37 Sheen Rd.
Richmond, Surrey, TW9 1A
UK

Mires Design, Inc.
2345 Kettner Blvd.
San Diego, CA 92101

no.parking
Contrá S. Barbara, 19
36100 Vicenza
Italy

Novodesign
Av. Infante Santo, 69 A/C
1350 Lisboa
Portugal

Nuno Alves
Rua Carvalho Araujo
2825 Monte de Caparica
Portugal

Osoxile, S.L.
Perill, 26
08012 Barcelona
Spain

Pat Carney Studio
400 1st Ave., North #614
Minneapolis, MN 55401

Pearlfisher
12 Addison Ave., Holland PK
London, W11 4QR
UK

Pentagram Design Inc.
204 Fifth Ave.
New York, NY 10010

PhotoDisc
2013 Fourth Ave.
Seattle, WA 98121

Port Miolla Associates
23 South Main St.
South Norwalk, CT 06854

R2 Design
Praceta D. Pereira 20 5°
sala FQ-4450
Matosinhos
Portugal

RTR Packaging & Design
27 W. 20th St.
New York, NY 10011

Roundel
7 Rosehart Mews
Westbourne Grove
London, W11 3TY
UK

Sayles Graphic Design
3701 Beaver Ave.
Des Moines, IA 50310

Seasonal Specialties LLC
11455 Valley View Road
Eden Prarie, MN 55344

Sibley/Peteet Design
3232 McKinney, Ste. 1200
Dallas, TX 75204

Studio Flux
800 Washington Avenue North, Ste. 304
Minneapolis, MN 55401

Studio GT&P di Gianluigi Tobanelli
Via Ariosto
5 - 06034 Foligno (PG)
Italy

TP Design
7007 Eagle Watch Ct.
Stone Mountain, GA 30087

Tau Diseño
Felipe IV, 8. 2° izda.
28014 Madrid
Spain

Tennis, anyone?
Kaserntorget 6
S-411 18 Göteberg
Sweden

Tharp Did It
Fifty University Ave., Ste. 21
Los Gatos, CA 95030

Thumbnail Productions Inc.
#101 1991 Cornwall Ave.
Vancouver, BC V6J 1C9
Canada

Tom Fowler, Inc.
9 Webbs Hill Road
Stamford, CT 06903

Turner Duckworth
164 Townsend St., No. 8
San Francisco, CA 94107

Twist
87 Wall St.
Seattle, WA 98121

2 Graphic Design
Wildersplads Block P
DK 1403 Copenhaghen K
Denmark

United Distillers/Vitners
UDU-NA, 750 Main Street
Stamford, CT 06902

Vaughn Wedeen Creative
407 Rio Grande Blvd., NW
Albuquerque, NM 87109

Viva Dolan
1216 Yonge St., Ste. 203
Toronto, ON M4T 1W1
Canada

Index

About the Author

Renée Phillips is the Associate Editor of *Dynamic Graphics* magazine, a how-to publication for desktop publishers. She has worked in and written about the graphic design and desktop publishing industry for ten years. She lives with her husband and son in Bloomington, Illinois.